LOS CAPRICHOS

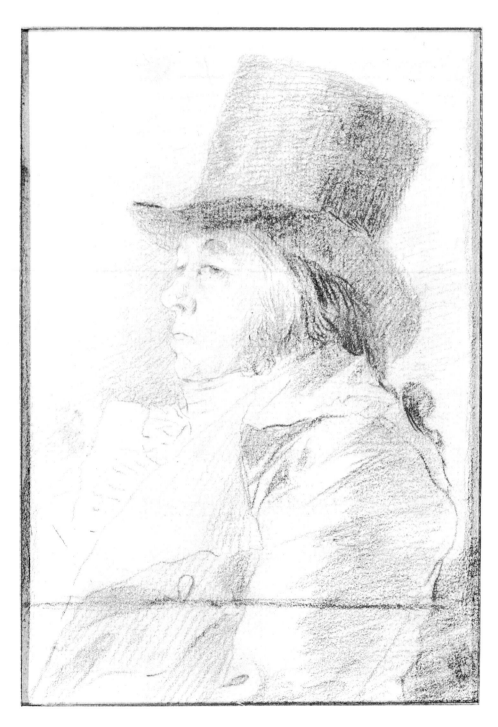

Self-portrait by Goya, preliminary drawing in red chalk for Plate 1 of *Los Caprichos* [courtesy Mr. Walter C. Baker, New York City]

LOS CAPRICHOS

by Francisco Goya y Lucientes

With a new Introduction by PHILIP HOFER

THE DEPARTMENT OF GRAPHIC ARTS

HARVARD UNIVERSITY LIBRARY

Dover Publications, Inc., New York

This Dover edition, first published in 1969, reproduces in its
entirety—with illustrations original size—one of the six known
pre-first-edition proof sets of the *Caprichos* (in the collection of
Mr. Philip Hofer, Cambridge, Mass.).

The present volume also includes a new Introduction by Mr.
Hofer, a list of plates, English translations of the Spanish captions,
and the Spanish text, with English translation, of the "Prado"
manuscript of commentary on the plates. The translations of the
captions and of the "Prado" manuscript (© Hilda Harris 1964)
are those first published in *Goya: Engravings and Lithographs*, by
Tomás Harris, and are used here by special arrangement with the
publisher, Bruno Cassirer, Oxford.

The frontispiece drawing is reproduced by courtesy of Mr. Walter
C. Baker, New York City.

The unique proofs of the early version of "Aquellos polbos" and
of "Old Woman and a Gallant" are reproduced by courtesy of the
Cabinet des Estampes, Bibliothèque Nationale, Paris.

The unique proofs of "Sueño de la mentira y la ynconstancia,"
"Woman in Prison" and "Women Weeping over an Injured Dog"
are reproduced by courtesy of the Gabinete de Estampas, Biblioteca
Nacional, Madrid.

The publisher is especially grateful to Mr. Hofer for his per-
mission to reproduce his proof set of the *Caprichos* and his hitherto
unpublished preliminary drawing for "El amor y la muerte," and
for his unfailing cooperation in the preparation of this volume.

Standard Book Number: 486–22384–1
Library of Congress Catalog Card Number: 69–14996

Manufactured in the United States of America
Dover Publications, Inc., 31 East 2nd Street, Mineola, N.Y. 11501

CONTENTS

INTRODUCTION TO

THE DOVER EDITION

Occasionally in the life of a very great artist some event, or some achievement, marks a turning point in his career. The publication of *Los Caprichos*, eighty aquatint plates, roughly $12\frac{1}{2}$ by $8\frac{3}{4}$ inches in their uncut state, was both these in Francisco Goya's case. The year was 1799, and one even knows the day, thanks to an advertisement in a newspaper, the *Diario de Madrid*. It was Tuesday, February 6th! Quite amusingly, the exact spot of publication was a shop for liquors and perfumes, in the "Street of Disillusion" (Calle del Desengaño) right opposite Goya's own house. The price was 320 reales, or about thirty-five dollars in our currency—a little less than forty cents a print (a fairly normal price for those days).

Despite this less than earth-shaking figure, the prints were not only Goya's largest graphic work to date—and he was already fifty-three years old—but a tremendous leap in quality and power above any prints he had ever done before. At an age when most artists are at the height of their career, he was only beginning to show his mastery of drawing, tone, and intellectual content. To be sure he was one of the court painters of King Carlos IV, but had he died before the drawings and prints for *Los Caprichos* were made, he would today be rated as an attractive painter of the pre-Revolutionary era and, in graphics, as mainly a reproductive etcher—not the major artist and the father of modern art which he had started to become.

INTRODUCTION TO THE DOVER EDITION

Goya became desperately ill in 1792 with a combination of nervous and physical troubles which cannot be completely explained even by the plausible suggestion that the artist was suffering from Ménière's disease in its worst form. Slowly in 1793 and 1794 he recuperated, although his friends Martín Zapater, Bernardo Yriarte, and Gaspar Melchor de Jovellanos, the Minister of Justice in 1797, despaired both for his life and his nervous stability. During the recovery period he did a lot of reading about the French Revolution, then at its most extreme period, and the philosophy which brought it about. When he was reasonably well again—although almost deaf—he was a changed man: bitter at times, secretive, far less exuberant. He was also able to express his new power, and proceeded to do so by preparing (with quite a number of pencil, crayon, and wash sketches) his aquatinted copper plates, from which he struck a few trial proofs, before letters, and six magnificent sets (so far recorded) of pre-publication proofs with captions, probably as gifts for his most important friends. These six sets have a few errors in the captions that were corrected in the first edition. It is from one of these six sets that the eighty basic *Caprichos* prints in the present volume were reproduced.

When the first edition was ready, Goya sat back, with some anxiety, to see what the public reception would be. The reason one knows that he was apprehensive is that he had changed his idea for the opening plate. Originally he intended what is now Plate 43 for this position since it shows the artist himself (although his face is hidden) suffering from the diabolic visions of his anguished brain. Goya's caption "The sleep of reason produces monsters" is deliberately deceptive. Thanks to the discovery of Miss Eleanor Sayre, Curator of the Department of Prints and Drawings in the Museum of Fine Arts, Boston, one is able to claim that Goya must have found inspiration in two engraved pictorial title pages to a Paris, 1793, edition of Jean-Jacques Rousseau's *Philosophie*. Supposing they reached Goya early in 1794, it would have been at the time of his recovery, the moment when one believes he was planning the *Caprichos* series, and keenly aware of the contrast between the "terror" in France and "reaction" in Spain. All the essential elements of Plate 43 are in those two pictorial title pages: the man leaning his head on a desk, the owls, the bats, and the great cat. The lettering on the side of the

desk is unique so far as this series is concerned. It could just as easily have contained the title, *Los Caprichos*, with the name of the artist and date.

Goya probably feared the source of his inspiration might be discovered and lead him into trouble with the political as well as clerical powers to whom the very name of Rousseau was then anathema. So he substituted a superb self-portrait, in profile, in which he wears what was later called a Bolívar hat, and had his name engraved (probably by a calligraphic artist) beneath it. Mr. Walter C. Baker, in New York City, owns the preliminary red chalk drawing (reproduced as the frontispiece of this volume)* for the present, and final, aquatint Plate 1.

There proved to be ample grounds for Goya's evasive action and for the elusive nature of the captions beneath each plate (except the first), for which half a dozen or more contemporary manuscript "explanations" exist. Probably the so-called "Prado" and "Ayala" manuscripts are the best (the text of the "Prado" manuscript is given in Spanish and English on the pages facing the etchings, just below the English translations of the captions). But no one manuscript is clearly authoritative; they vary in the power of their prose, and the conviction which the "explanation" carries. One of these manuscripts, which now belongs to the writer of this introduction, may be by Llorente, who was Secretary of the Spanish Inquisition. In any case, the hue and cry became so great that after only twenty-seven copies had been bought, Goya was forced to suspend sales. Finally in 1803 the whole matter was covered up when the boorish, bumbling King, who liked Goya personally, ordered the

* The present edition also contains reproductions of the following items in addition to the eighty basic *Caprichos* plates: a hitherto unpublished preliminary drawing for "El amor y la muerte" (No. 10) owned by the writer of this introduction; the unique proofs of an earlier version of "Aquellos polbos" (No. 23) and of "Old Woman and a Gallant" (from a plate probably originally intended for the *Caprichos*; both in the Bibliothèque Nationale, Paris); and the unique proofs of "Sueño de la mentira y la ynconstancia," probably intended for the *Caprichos*, of "Woman in Prison," possibly an earlier version of "Por que fue sensible" (No. 32), and of "Women Weeping over an Injured Dog," probably intended for the *Caprichos* (all in the Biblioteca Nacional, Madrid).

artist to give to the crown all the unsold sets, as well as the copper plates themselves, which he said he had "expressly ordered Goya to make." This order saved Goya both from the political right and from the Inquisition. Yet the purchaser of this series of reproductions will notice how often political or anticlerical caricatures can be inferred.

For instance, Plate 23, entitled "Aquellos polbos" (Those specks of dust), represents the passing of a sentence on an offender against the Inquisition. The prisoner is robed in the dread penitential dress called the "San Benito." The title recalls a Spanish proverb: "This dust produces that mud." But Goya has been purposely equivocal. It is not simply that the prisoner has been brought to justice for his offense. There is a deeper layer of meaning. At whom is Goya's anger leveled? At the prisoner, or at the cruel judge (at the right), or at the populace who come to stare and to gloat?

Similarly, in Plate 6, "Nadie se conoce" (Nobody knows himself), Goya possibly expected a number of people to recognize the masked young woman at the right because of the attendant figures and the gossip of the day, just as they might recognize the woman who is being carried away in Plate 8 and the fine lady in Plate 36 who is returning on a windy night with her duenna—despite the fact that her face has been covered by her blowing scarf. According to contemporary rumor, this personage could have been the Spanish Queen returning to the palace from a midnight tryst. Neither the Ayala nor Prado manuscript leveled this accusation—a later art historian, Paul Lefort, did. Professor José López-Rey suggests the caption may refer to a current Spanish pun; Goya also invoked a pun in No. 26.

Plate 39 is pure political caricature where both the two chief manuscript explanations happily agree. They say that this donkey (or ass) has been driven mad by genealogies. In this case is it a known member of the Spanish intellectuals? Or is it the unpopular favorite of the Queen, the Prime Minister Godoy, who had had his ancestry traced back, in a current publication, to the Visigothic Kings of Spain?

Plates 52 and 53 are clearly anticlerical again: the scarecrow to whom the ignorant peasant woman is praying wears a monk's cowl and gown,

thinly disguised;* the monks who listen to the parrot praise it for its "golden beak" as it preaches to them. The ugly woman in Plate 55 will try on lovely new bonnets until her dying day, while one of the onlookers, at least, will titter. Was she the Duchess of Benavente, mother of the Duque de Osuna, still vain at the age of seventy-five? Why was the woman in Plate 32 imprisoned "for being too sensitive"? All one can surely say here is that Goya's mastery of the new aquatint technique was never better displayed, for the plate does not contain a single etched line. It is entirely made up of brush washes achieved by successive "stoppings out" of elements in the composition and rebitings of the plate in an acid bath until there are a dozen gradations of tonal value.

The artist's amazing power of continued intellectual and technical growth—learning long past the age when lesser artists have become static—is convincingly displayed in the *Caprichos* series. Goya was a late starter. He only began to hit his stride in *Los Caprichos*. And he still had almost thirty years of achievement ahead since he did not die until he was eighty-two (in 1828).

Almost all the last plates of this print series, from about Plate 58 on, are fantastic and allegorical. Many are among the most beautiful Goya ever made. Plate 64, "Buen Viage," is a case in point, since it is filled with mystery. The Prado manuscript offers a poetic interpretation: "Where is this infernal company going, filling the air with noise in the darkness of night? If it were daytime it would be quite a different matter and gun shots would bring the whole group of them to the ground; but as it is night, no one can see them."

"Ya es hora" (It is time), *Caprichos* Plate 80, concludes the published series on a diabolic note. It is the tocsin call to awaken at the last split second of a nightmare's hold. After all none of this was really "true"— just the figment of a disordered imagination, as Joseph Addison says in his essay "On the Pleasures of the Imagination" (*Spectator*, July 3, 1712), which Goya's friend José Luis Munárriz translated: "When the brain is hurt by an accident, or the mind disordered by dreams or

* A unique trial proof of Plate 52 in the collection of the writer of this introduction shows the cowl without a "topknot" (i.e., exactly like a monk's cowl). So also does a preliminary drawing in the Prado.

sickness, the fancy is overrun with wild dismal ideas, and terrified with a thousand hideous monsters of its own framing."

This passage may well be the chief literary source for Goya's series of caprices since it is very nearly biographical for him. But Goya's imagination in this case did not lead him into error, but rather onto a higher plane of artistic achievement than almost any caricaturist and social commentator before his time.

PHILIP HOFER

Cambridge, Mass.
April, 1969

LIST OF PLATES

7

LIST OF PLATES

8

PLATES

[1] Francisco Goya y Lucientes, Painter

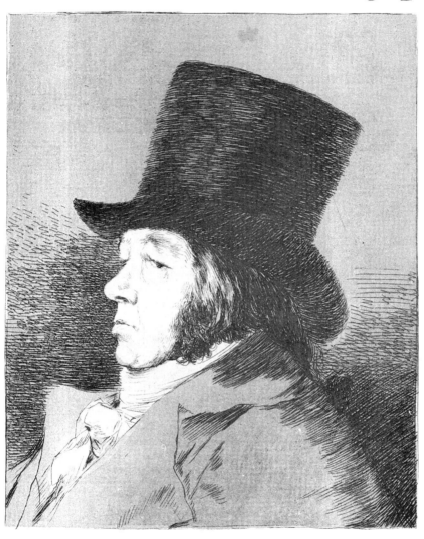

Fran.co Goya y Lucientes
Pintor.

[2] They say yes and give their hand to the first comer

The readiness with which many women are inclined to get married, hoping thereby to be able to live in greater liberty · *Facilidad con q.ᵉ muchas mugeres se prestan à celebrar matrimonio esperando vivir en el con mas libertad.*

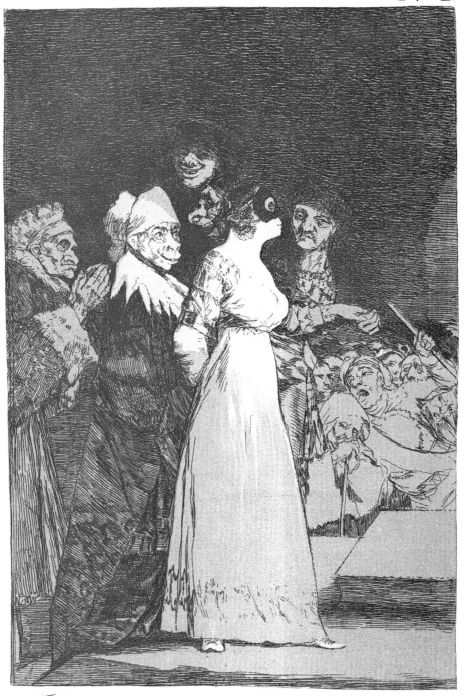

El si pronuncian y la mano alargan
Al primero que llega.

[3] Here comes the bogey-man

Lamentable abuse of early education. To cause a child to fear the bogey-man more than his father and so make it afraid of something that does not exist ·
Abuso funesto de la primera educacion. Hacer q.ᵉ un niño tenga mas miedo al coco q.ᵉ a su padre, y obligarle à temer lo q.ᵉ no existe.

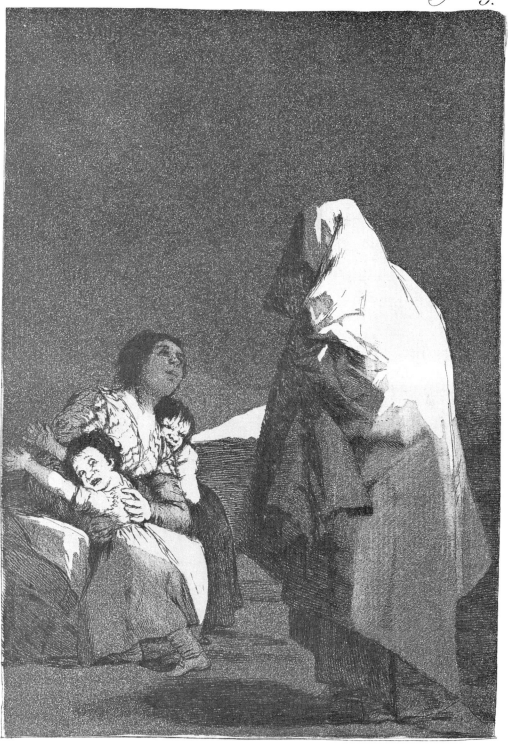

Que biene el Coco.

[4] Nanny's boy

Negligence, tolerance and spoiling make children capricious, naughty, vain, greedy, lazy and insufferable. They grow up and yet remain childish. Thus is nanny's little boy · *La negligencia, la tolerancia y el mimo hacen à los niños antojadizos obstinados soberbios golosos perezosos e insufribles. Llegan à grandes y son niños todavia. Tal es el de la rollona.*

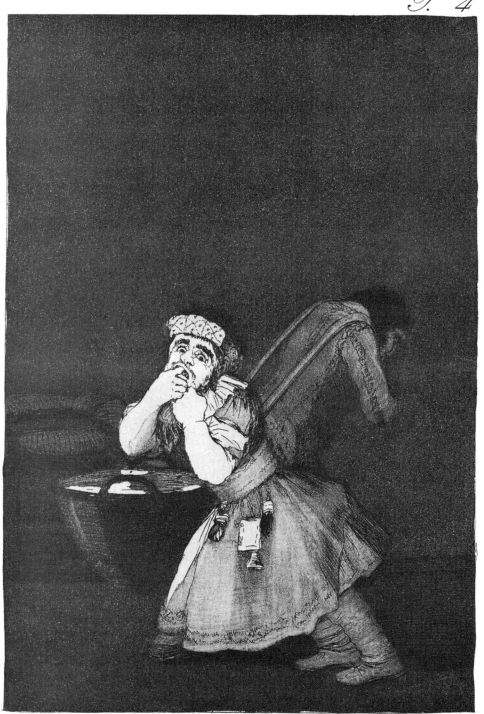

El de la royona.

[5] Two of a kind

It is often disputed whether men are worse than women or the contrary, but the vices of the one and the other come from bad upbringing. Wherever the men are depraved, the women are the same. The young lady portrayed in this print is as knowing as the young coxcomb talking to her, and as regards the two old women, one is as vile as the other · *Muchas veces se ha disputado si los hombres son peores q? las mugeres o lo contrario. Los vicios de unos y otros vienen de la mala educacion donde quiera q? los hombres sean perversos las mugeres lo seran tambien. Tan buena cabeza tiene la señorita q? se represt?a en esta estampa como el pisaverde q? le esta dando conversacion, y en quanto a las dos viejas tan infame es la una como la otra.*

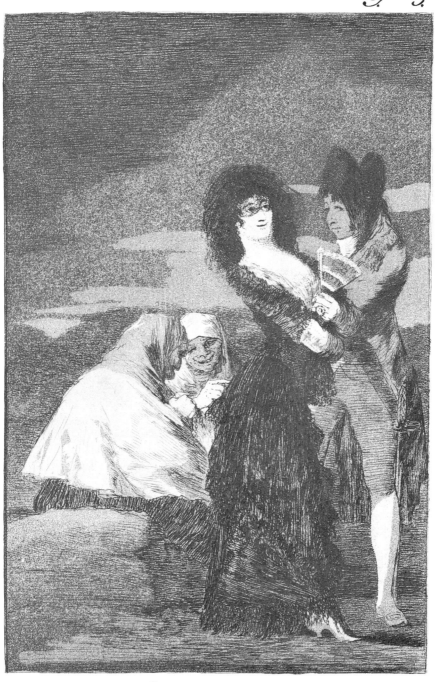

Tal para qual.

[6] Nobody knows himself

The world is a masquerade. Face, dress and voice, all are false. All wish to appear what they are not, all deceive and do not even know themselves · *El mundo es una mascara, el rostro, el trage y la voz, todo es fingido. Todos quieren aparentar lo q.ᵉ no son, todos engañan y nadie se conoce.*

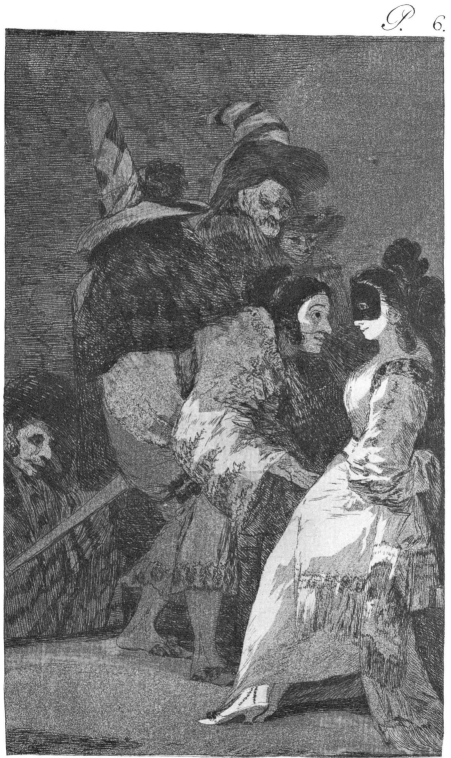

Nadie se conoce.

[[7]] Even thus he cannot make her out

How can he make her out? In order to know what she is, a monocle is not enough; judgment and experience of the world are needed and these are precisely what this poor gentleman is lacking · *Como ha de distinguirla? Para conocer lo qᵉ ella es no basta el anteojo se necesita juicio y practica de mundo y esto es precisamente lo qᵉ le falta al probre caballero.*

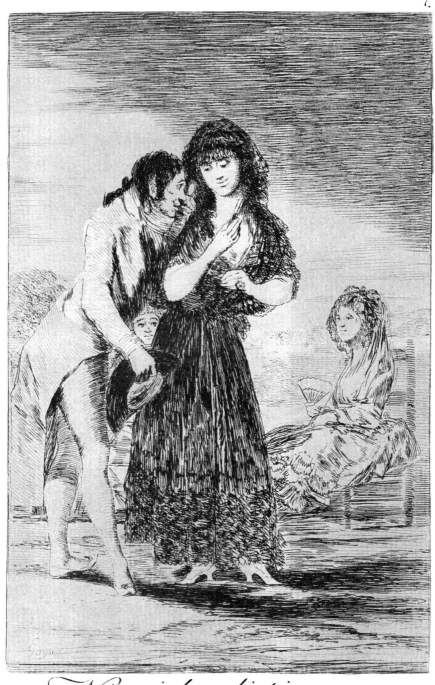

Ni asi la distingue.

[8] They carried her off!

The woman who cannot take care of herself belongs to the first who seizes her, and when the mischief is done, people are surprised that she has been carried off · *La muger q*e*. no se sabe guardar es del primero q*e*. la pilla y quando ya no tiene remedio se admiran de q*e*. se la llevaron.*

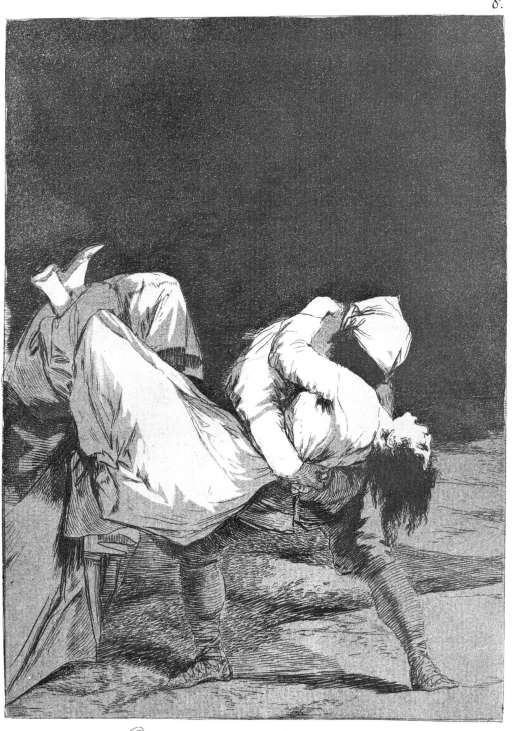

Que se la llevaron.

[9] Tantalus

If he were a better lover and less of a bore, she would revive · *Si el fuese mas galan y menos fastidioso ella reviviria.*

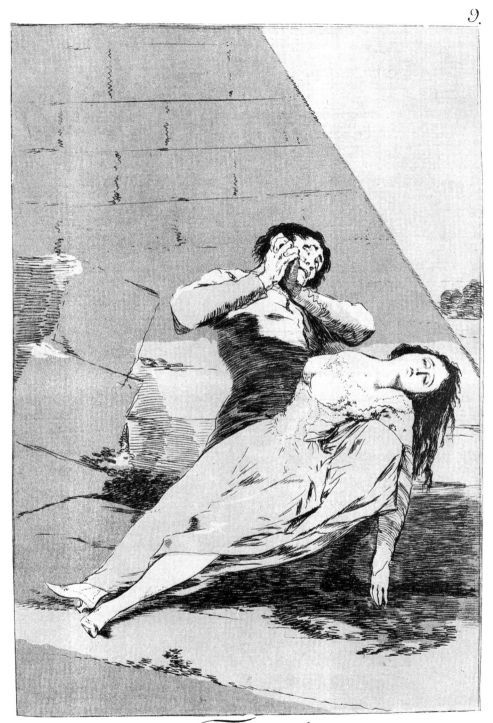

Tantalo.

[**10**] Love and death

See here a Calderonian lover who, unable to laugh at his rival, dies in the arms of his beloved and loses her by his daring. It is inadvisable to draw the sword too often · *Ve aqui un amante de Calderon q.^e p.^r. no saberse reir de su competidor muere en brazos de su querida y la pierde por su temeridad. No conviene sacar la espada muy amenudo.*

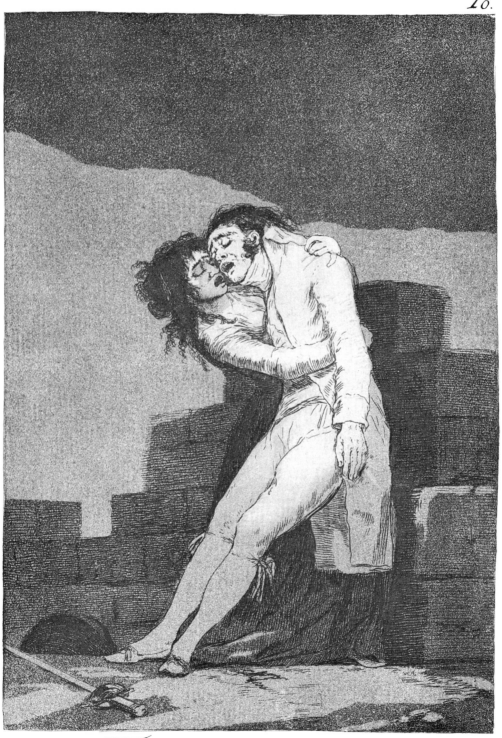

El amor y la muerte.

[II] Lads making ready

Their faces and clothes make it clear what they are · *Las caras y el trage estan diciendo lo qᵉ ellos son.*

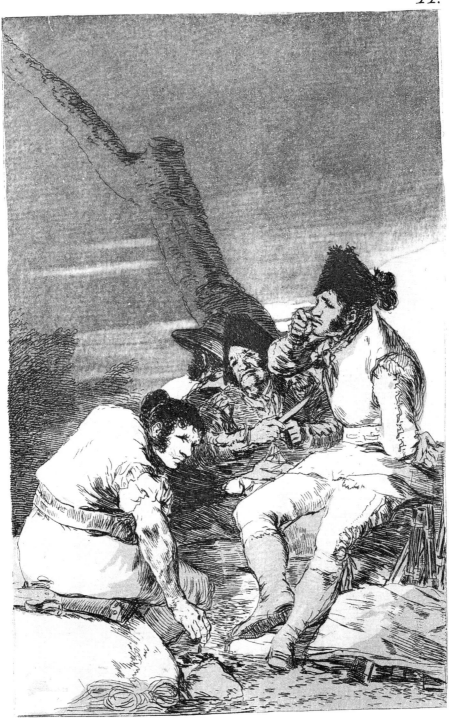

Muchachos al avío.

[12] Out hunting for teeth

The teeth of a hanged man are very efficacious for sorceries; without this
ingredient there is not much you can do. What a pity the common people
should believe such nonsense · *Los dientes de ahorcado son eficacisimos p.ª los
ēchizos sin este ingrediente no se hace cosa de probecho. Lastima es q.ᵉ el vulgo crea
tales desatinos.*

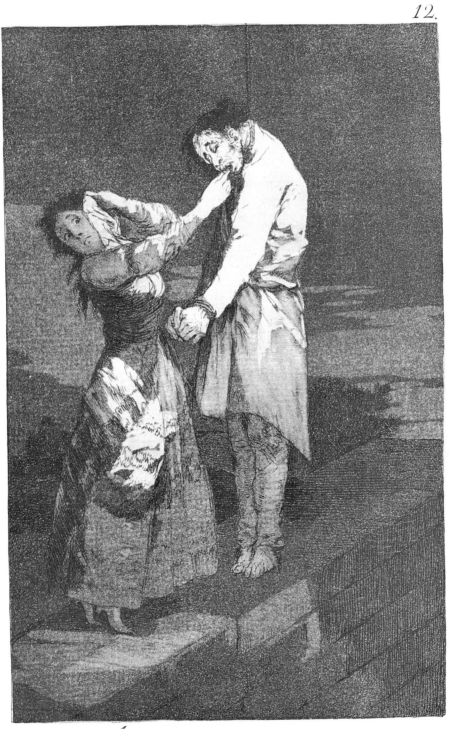

A caza de dientes.

[13] They are hot

They are in such a hurry to gobble it down that they swallow it boiling hot.
Even in pleasure, temperance and moderation are necessary · *Tal prisa
tienen de engullir q? se las tragan hirbiendo. Hasta en el uso de los placeres son
necesarias la templanza y la moderacion.*

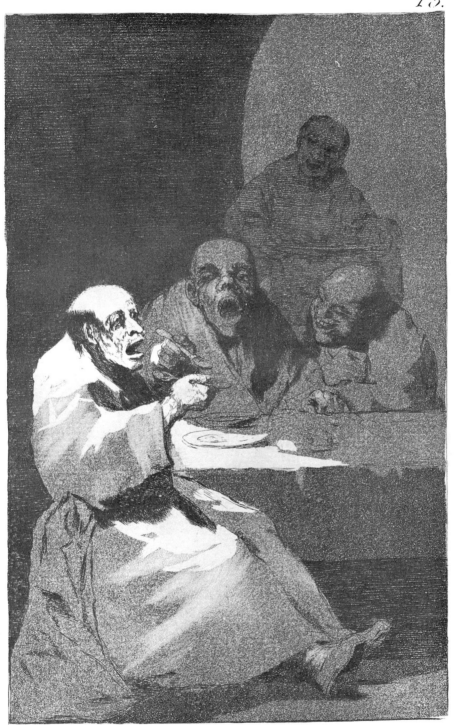

Estan calientes.

[14] What a sacrifice!

That's how things are! The fiancé is not very attractive, but he is rich, and at the cost of the freedom of an unhappy girl, the security of a hungry family is acquired. It is the way of the world · *Como ha de ser el novio no es de los mas apetecibles pero es rico y á costa de la libertad de una niña infeliz se compra el socorro de una familia hambrienta. Asi va el mundo.*

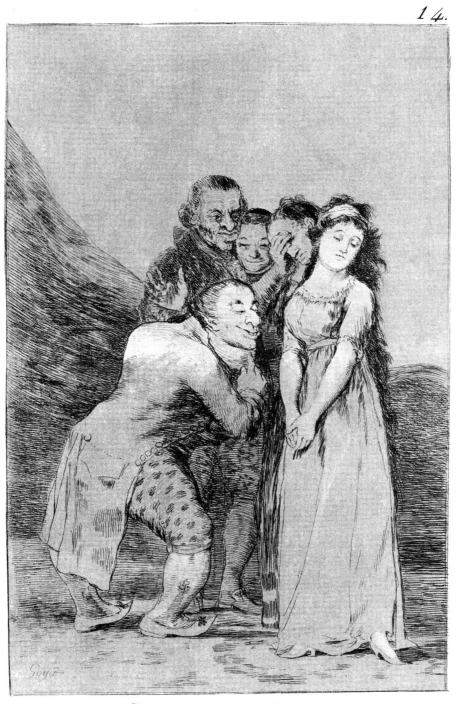

Que sacrificio!

[15] Pretty teachings

The advice is worthy of her who gives it. The worst of it is that the girl will follow it absolutely to the letter. Unhappy the man who gets anywhere near her · *Los consejos son dignos de quien los da. Lo peor es q.ᵉ la señorita va a seguirlos al pie de la letra. Desdichado del que se acerque!*

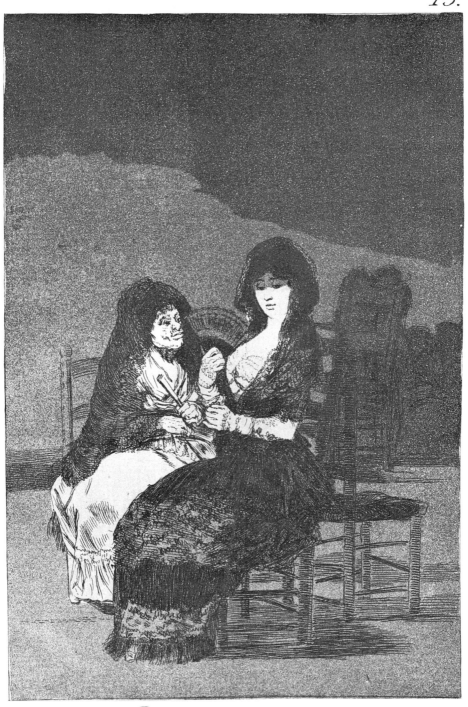

Bellos consejos.

[16] For heaven's sake: and it was her mother

The young woman left her home as a little girl. She did her apprenticeship at
Cadiz, she came to Madrid: there she "won the lottery." She goes down to the
Prado, and hears a grimy, decrepit old woman begging her for alms; she sends
her away, the old woman persists. The fashionable young woman turns round
and finds—who would have thought it—that the poor old woman is her
mother · *La señorita salio muy niña de su tierra: hizo su aprendizaje en Cadiz,
vino à Madrid: la cayo la loteria. Baja al Prado, oye q^e. una vieja mugrienta y
decrepita la pide limosna, ella la despide ynsta la vieja. Vuelvese la petrimetra y
halla . . . quien lo diria? q^e. la pobretona es su madre.*

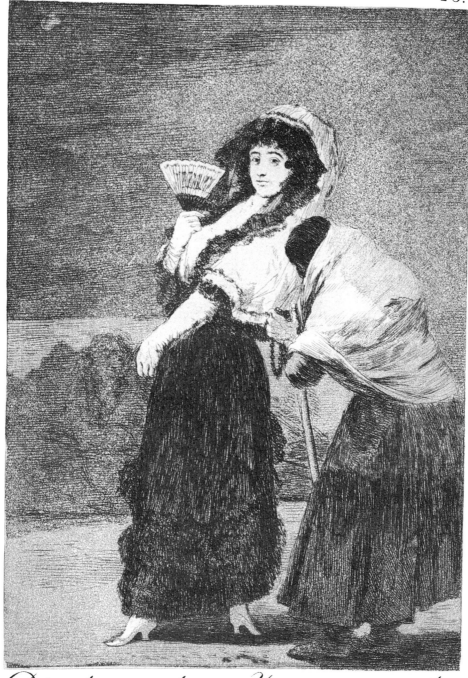

Dios la perdone: Y era su madre.

[**17**] It is nicely stretched

Oh! The bawdy old woman is no fool! She knows quite well what is wanted, and that the stockings must fit tightly · *Oh! La tia curra no es tonta. Bien sabe ella lo que conviene q.ᵉ las medias vayan estiraditas.*

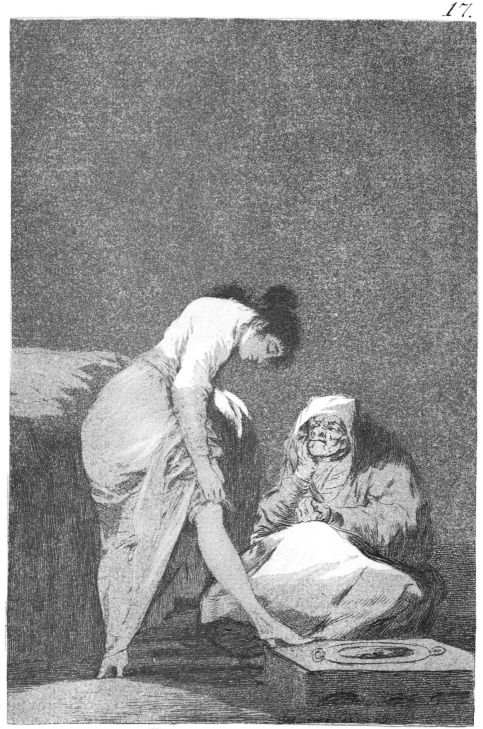

Bien tirada está.

[18] And his house is on fire

It will not occur to him to take off his breeches or to stop talking to the candle, until the local fire brigade freshens him up. Wine can do as much as that · *Ni acertara ā quitarse los calzones ni dejar de hablar con el candil, hasta qᵉ. las bombas de la villa le refresquen. Tanto puede el vino!*

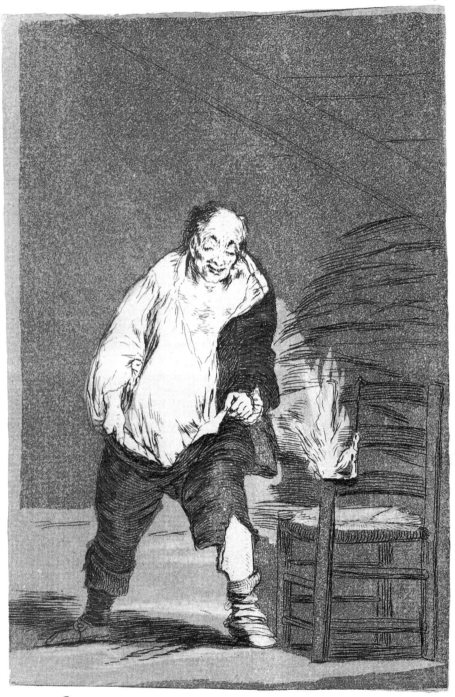

Ysele quema la Casa.

[19] All will fall

And those who are about to fall will not take warning from the example of those who have fallen! But nothing can be done about it: all will fall · ¡Y que no escarmienten los qᵉ van à caer con el exemplo de los qᵉ han caido! pero no hay remedio todos caeran.

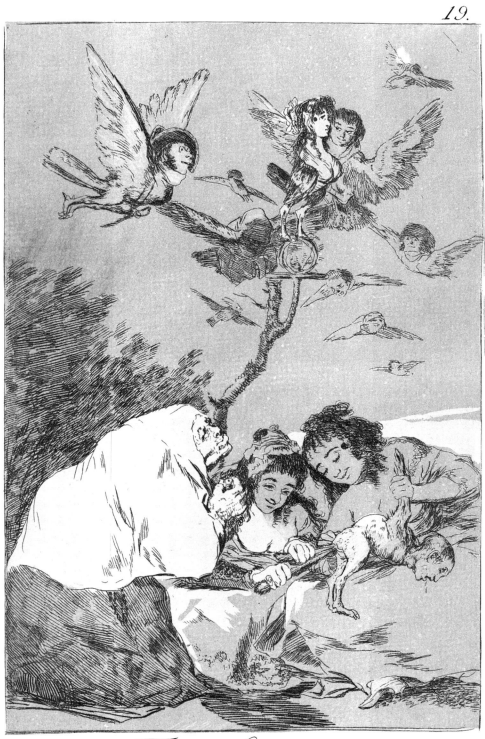

Todos Caerán.

[20] There they go plucked (i.e. fleeced)

If they have already been plucked, get them out: there will be others coming along · *Si se desplumaron ya, vayan fuera: qe van à venir otros.*

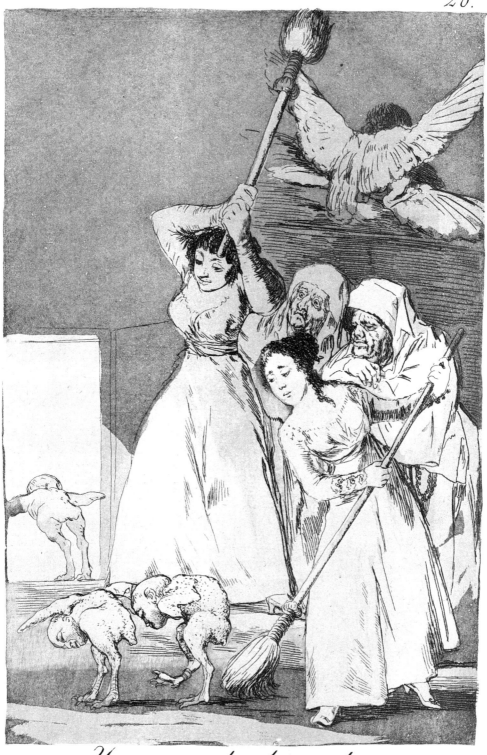

Ya van desplumados.

[2I] How they pluck her!

Hens (pretty lasses) also encounter birds of prey to pluck them and that is why the saying goes: you'll get as good as you give · *Tambien las Pollas encuentran milanos qᵉ las desplumen y aun por eso se dijo aquello de: Donde la dan las toman.*

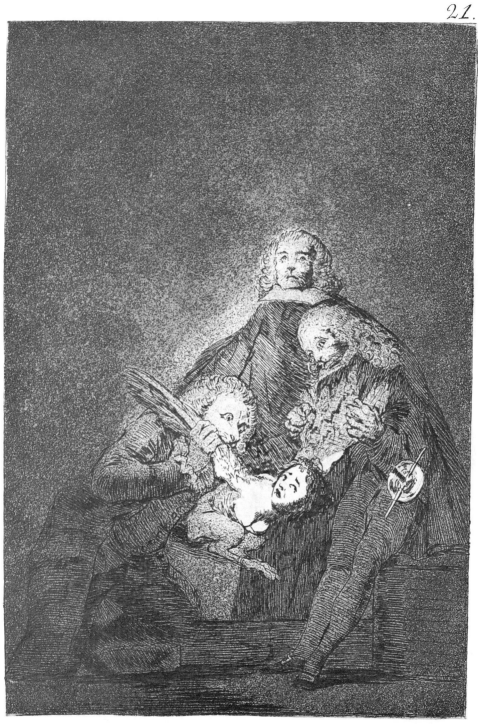

¡Qual la descañonan!

[22] Poor little girls!

They are going to mend these tattered women; take them in as they have been
getting loose for long enough · *Vayan à coser las descosidas. Recojanlas q?*
bastante anduvieron sueltas.

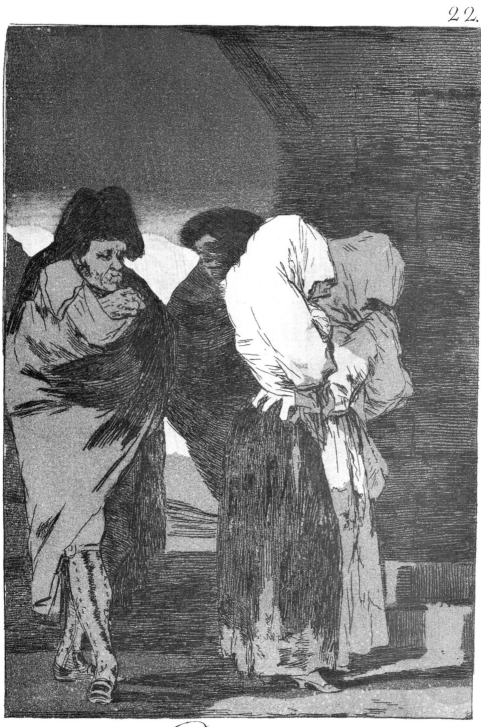

Pobrecitas!

[23] Those specks of dust

For shame! To treat in this way an honorable woman who for a trifle served everyone so diligently, so usefully! For shame! · *Mal hecho! A una mujer de ōnor, qᵉ por una friolera servia ā todo el mundo tan delijente, tan util, tratarla asi! mal hecho!*

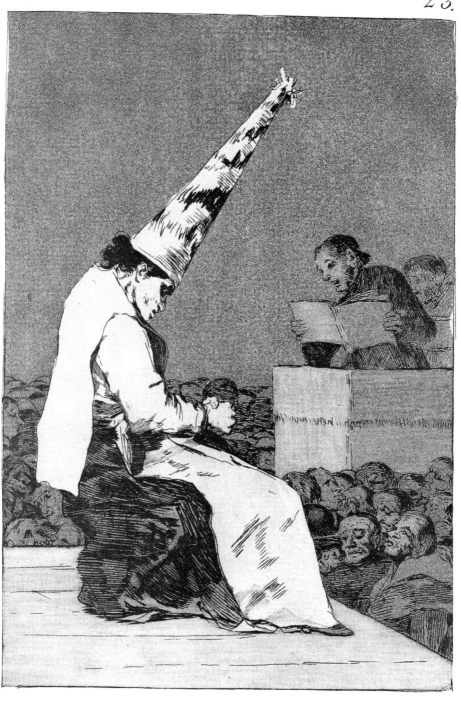

Aquellos polbos.

[24] Nothing could be done about it

They are persecuting this saintly woman to death! After having signed her death sentence, they take her out in triumph. She has indeed deserved a triumph and if they do it to insult her they are wasting time. No one can shame someone who has nothing to be ashamed of · *A esta S^{ta} S^{ra} la persiguen de muerte! despues de escrivirla la vida la sacan en triunfo. Todo se lo merece, y si lo hacen p^r. afrentarla es tiempo perdido. Nadie puede abergonzar a quien no tiene verguenza.*

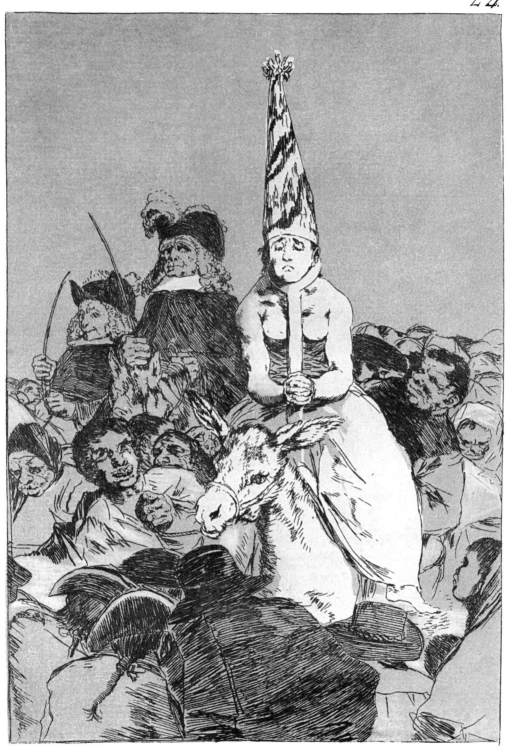

Nohubo remedio.

[25] Yes he broke the pot

The son is mischievous and the mother bad tempered. Which is worse? · *El hijo es travieso y la madre colerica. Qual es peor.*

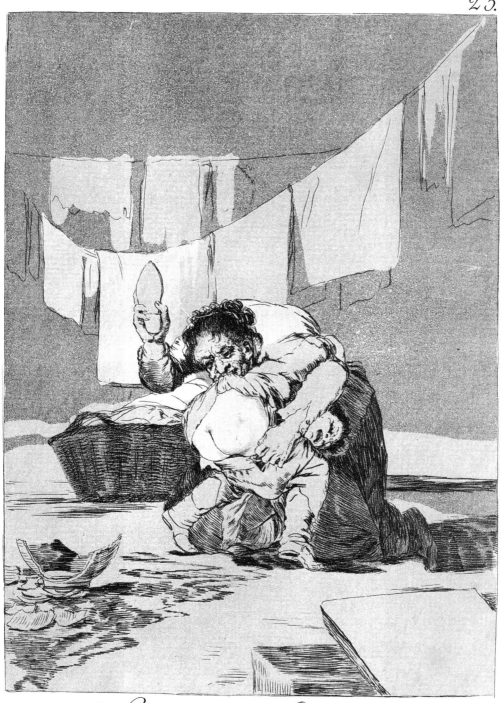

Si quebró el Cantaro.

[26] They've already got a seat (i.e. bottom)

If conceited girls want to [show they] have a seat, there is nothing better than to put it on their head · *Para q? las niñas casquibanas tengan asiento no hay mejor cosa q? ponerselo en la cabeza.*

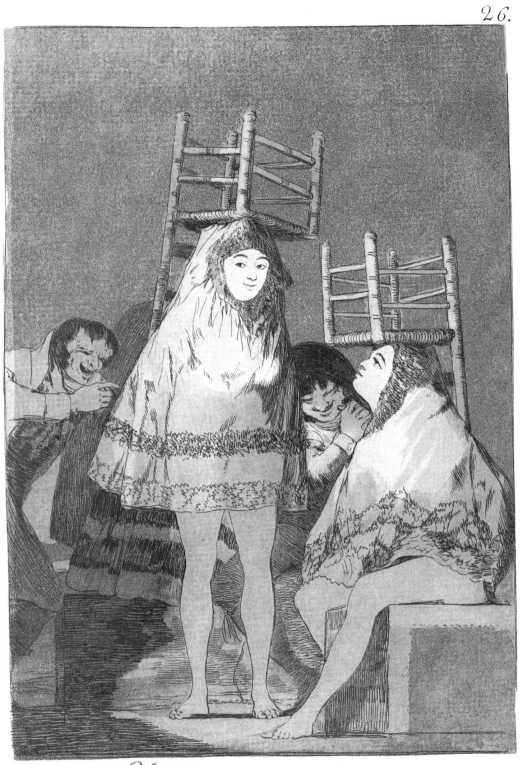

Ya tienen asiento.

Which of them is the more overcome?

Neither one nor the other. He is a charlatan in love who says the same to all of them, and she is thinking of giving up five appointments which she had made between 8 and 9 and it's already 7.30 · *Ni uno ni otro. El es un charlatan de amor que a todas dice lo mismo y ella esta pensando en evacuar 5 citas q.ᵉ tiene dadas entre 8 y 9 y son las 7 y ½.*

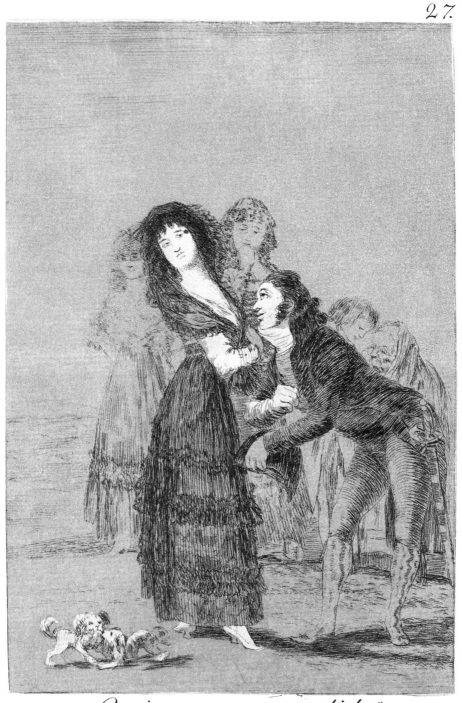

Quien mas rendido?

[28] Hush

An excellent mother to trust with a confidential commission · *Excelente madre para un encargo de confianza.*

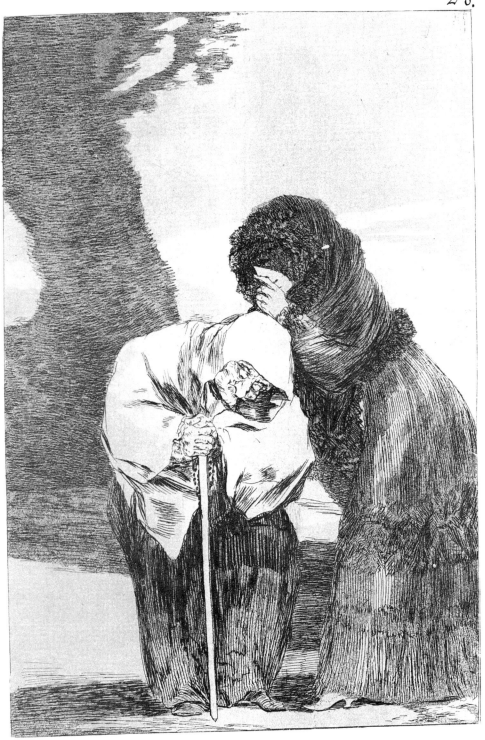

Chiton.

[29] That certainly is being able to read

They are combing his hair, they are putting on his shoes, he is sleeping and he is studying. No one shall say that he is not making the most of his time · *Le peinan, le calzan, duerme, y estudia. Nadie dira q.ᵉ desaprobecha el tiempo.*

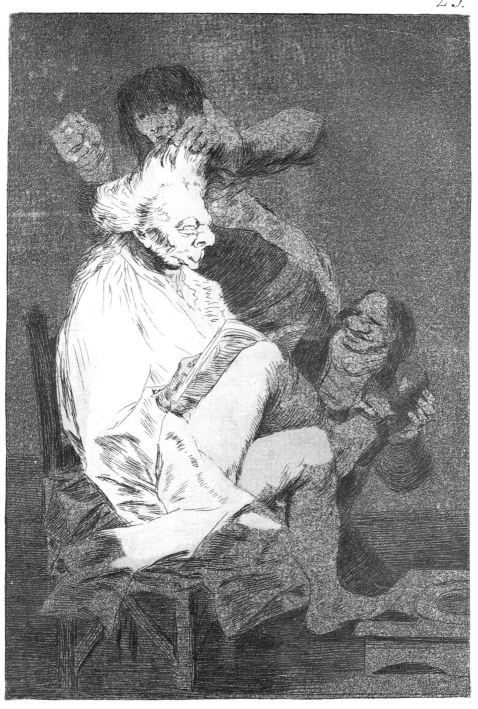

Esto si que es leer.

[30] Why hide them ?

The answer is easy. The reason he doesn't want to spend them and does not spend is because although he is over eighty and can't live another month, he still fears that he will live long enough to lack money. So mistaken are the calculations of avarice · *La respuesta es facil. Porque no los quiere gastar y no los gasta porqᵉ. aun qᵉ. tiene los 80 cumplidos y no puede vivir un mes todavia teme qᵉ. le ha de sobrar la vida y faltarle el dinero. Tan equibocados son los calculos de la avaricia.*

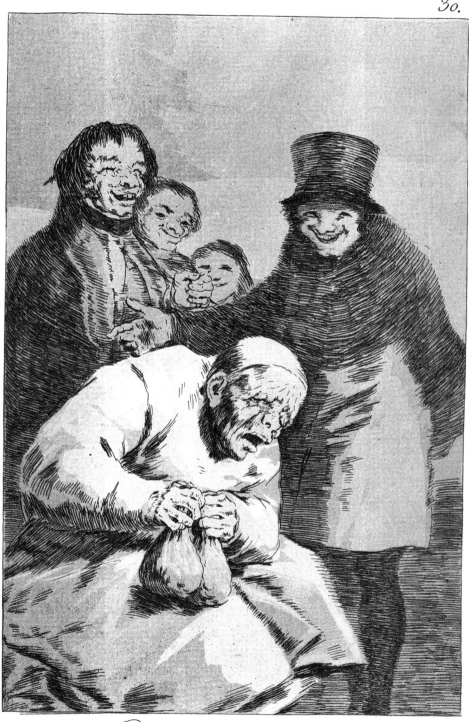

Porque esconderlos?

[31] She prays for her

And she does well to do so, that God may send her luck and keep her from harm and from surgeons and policemen and make her as dexterous and wide awake and willing as her mother who is in heaven · *Y hace muy bien para qe. Dios le de fortuna y la libre de mal y de cirujanos y Alguaciles, y llegue à ser tan diestra tan despejada y tan para todos como su madre que en gloria este.*

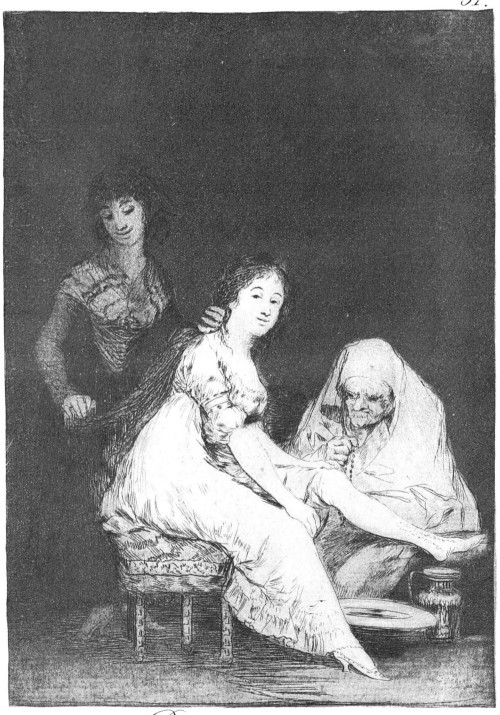

Ruega por ella.

[32] Because she was susceptible

It had to happen. The world has its ups and downs. The life she·was leading could end in no other way · *Como ha de ser este mundo tiene sus altos y bajos. La vida q̣: ella trahia no podia parar en otra cosa.*

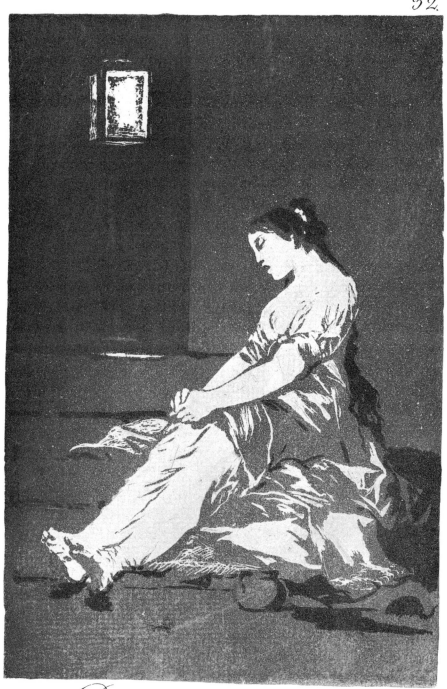

Por que fue sensible.

[33] To the Count Palatine or Count of the Palate

In all sciences there are quacks who know everything without having studied a word and have a remedy for everything. You should not trust a word they say. The really wise man is always wary of making predictions: he promises little and accomplishes a lot; but the Count Palatine accomplishes nothing of what he promises · *En todas ciencias hay charlatanes qᵉ sin haber estudiado palabra lo saben todo y para todo hallan remedio. No hay qᵉ fiarse de lo qᵉ anuncian. El verdadero sabio desconfia siempre del acierto: promete poco y cumple mucho; pero el Conde Palatino, no cumple nada de lo qᵉ promete.*

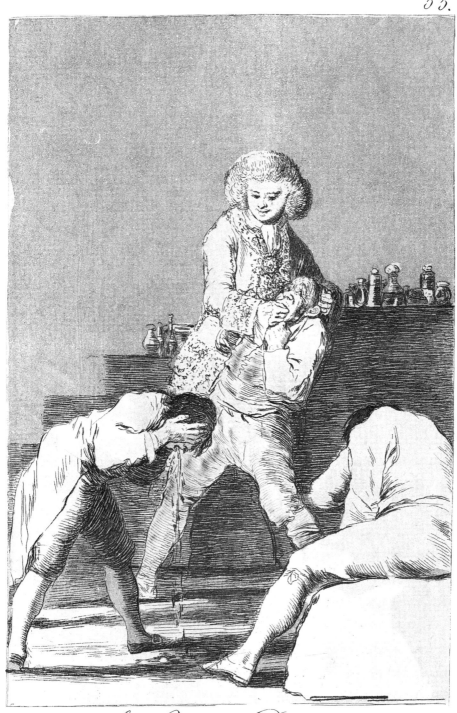

Al Conde Palatino.

[34] Sleep overcomes them

Don't wake them! Sleep is perhaps the only happiness of the wretched · *No hay q^e dispertarlas tal vez el sueño es la unica felicidad de los desdichados.*

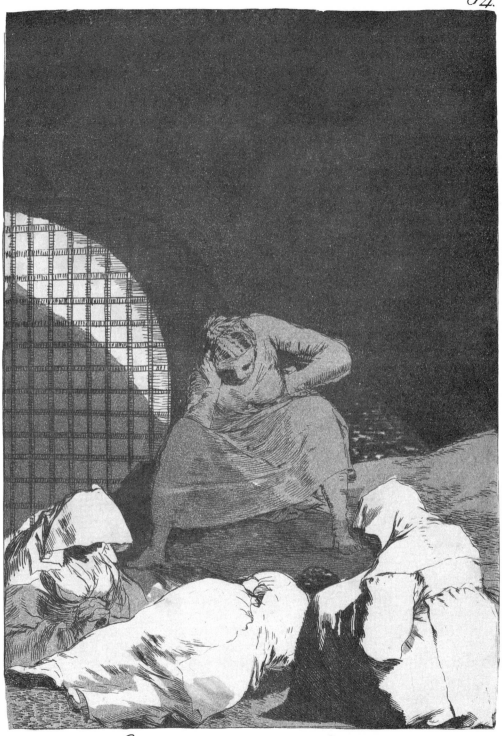

Las rinde el Sueño.

[35] She fleeces him

They shave him close and fleece him. It is his own fault for putting himself in the hands of such a barber · *Le descañonan y le desollaran. Le culpa tiene quien se pone en mañ. de tal Barbero.*

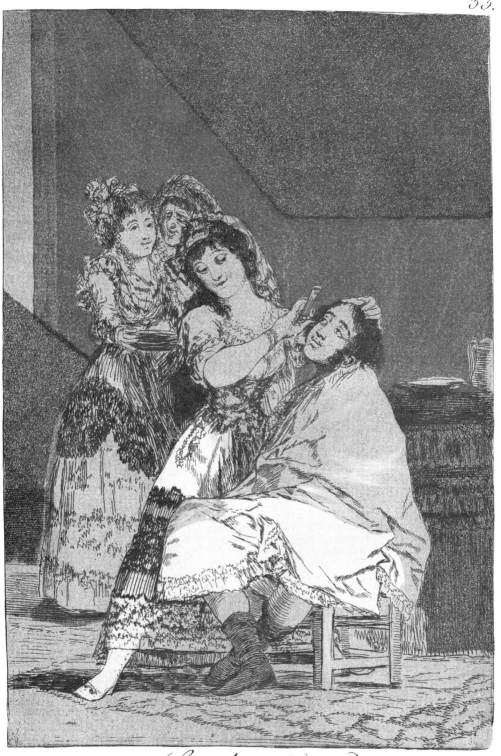

Le descañona.

[36] A bad night

Gadabout girls who don't want to stay at home, risk exposing themselves to these hardships · *A esto trabajos se esponen las niñas pindongas qᵉ. no se quieren estar en casa.*

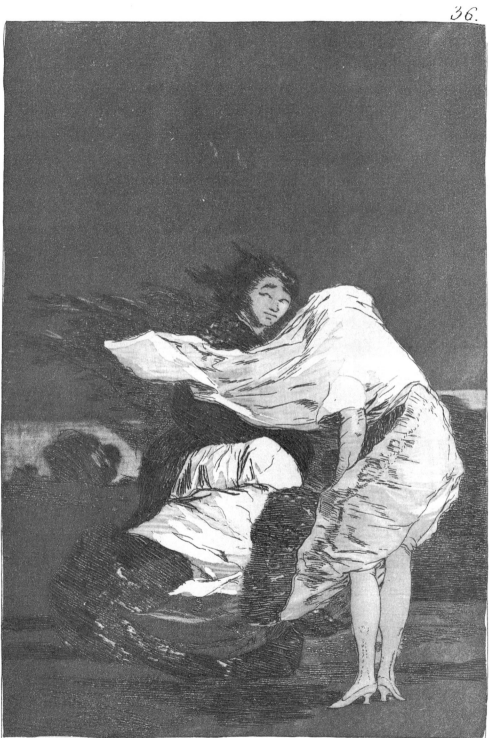

Mala noche.

[37] Might not the pupil know more?

One cannot say whether he knows more or less; what is certain is that the master is the most serious-looking person who could possibly be found · *No se sabe si sabra mas ō menos lo cierto es qᵉ. el maestro es el personage mas grabe qᵉ. se ha podido encontrar.*

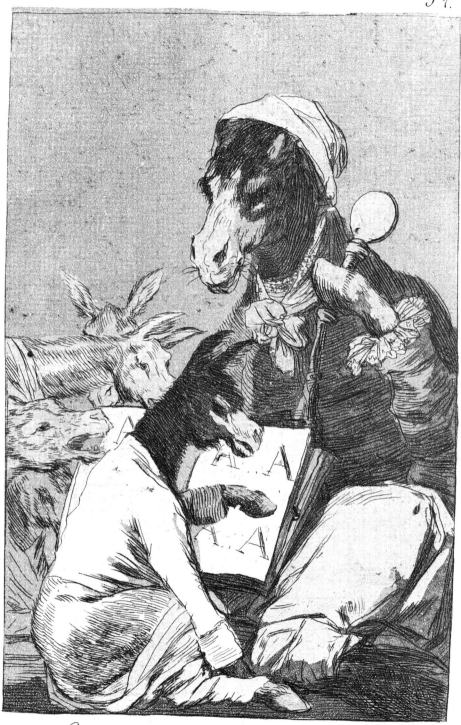

Si sabrà mas el discipulo?

[38] Bravo!

If ears were all that were needed to appreciate it, no one could listen more intelligently; but it is to be feared that he is applauding what is soundless · *Si para entenderlo bastan las orejas nadie habra mas intelligente; pero es de temer q̃ᵉ aplauda lo q̃ᵉ no suena.*

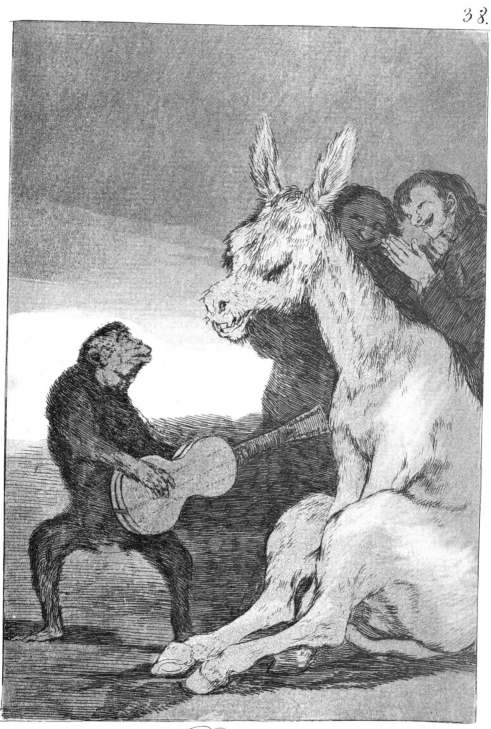

Brabisimo!

[39] And so was his grandfather

This poor animal has been driven mad by Genealogists and Heralds. He's not the only one · *A este pobre animal le han vuelto loco los Genialogistas y reyes de Armas. No es el solo.*

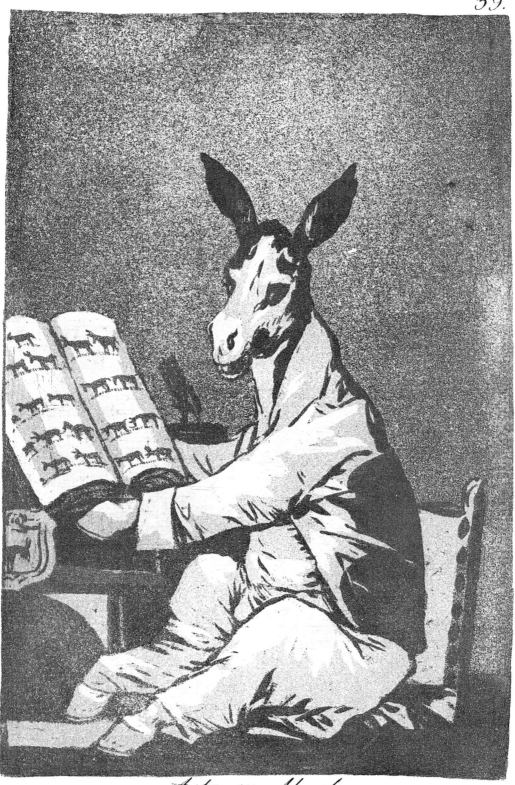

Asta su Abuelo.

[40] Of what ill will he die?

.

The doctor is excellent, pensive, considerate, calm, serious. What more can one ask for? · *El medico es excel.te meditabundo, reflexibo, pausado serio. Que mas hay q.e pedir?*

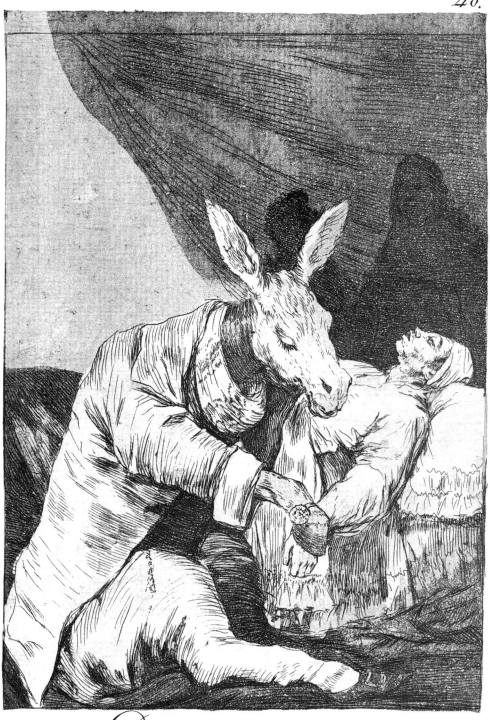

De que mal morira?

[4I] Neither more nor less

He is quite right to have his portrait painted; thus those who do not know him
and have not seen him will know who he is • *Hace muy bien en retratarse: asi
sabran quien es los qᵉ. no le conozcan ni ayan visto.*

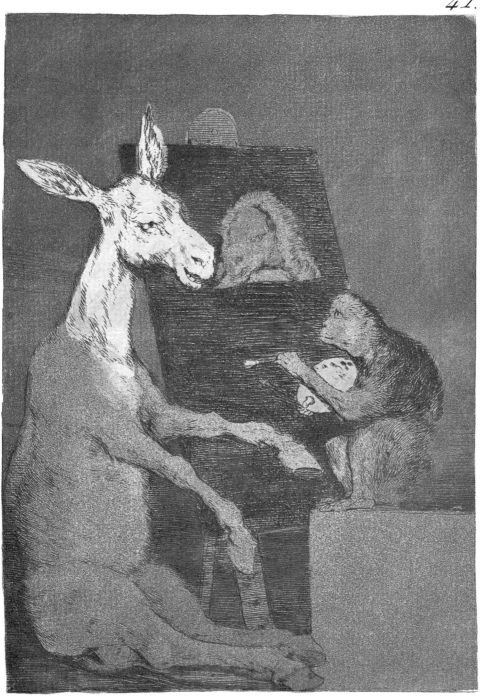

Ni mas ni menos.

[42] Thou who canst not

Who would not say that these two cavaliers are cavalry (riding beasts)? ·
Quien no dira que estos dos caballeros son caballerias?

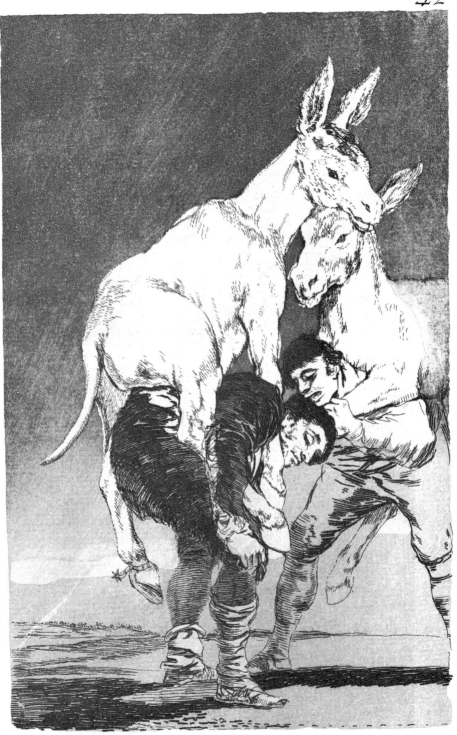

Tu que no puedes.

[43] The sleep of reason produces monsters

Imagination abandoned by reason produces impossible monsters: united with her, she is the mother of the arts and the source of their wonders · *La fantasia abandonada de la razon, produce monstruos imposibles: unida con ella, es madre de las artes y origen de sus marabillas.*

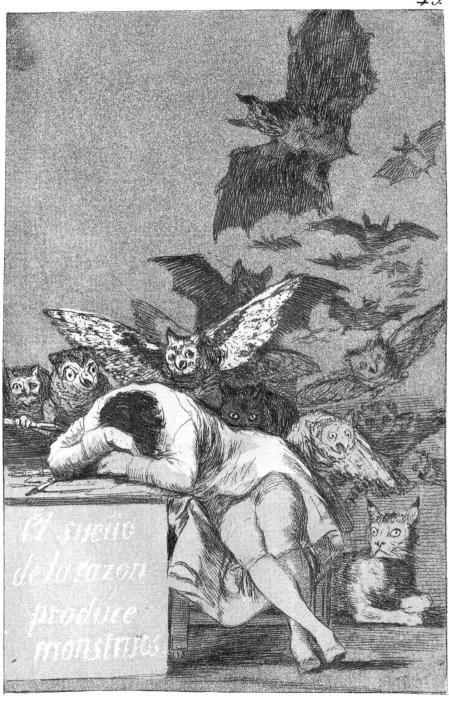

El sueño de la razon produce monstruos.

[44] They spin finely

They spin finely and the devil himself will not be able to undo the warp which they contrive · *Hilan delgado y la trama qᵉ. urden ni el diablo la podra deshacer.*

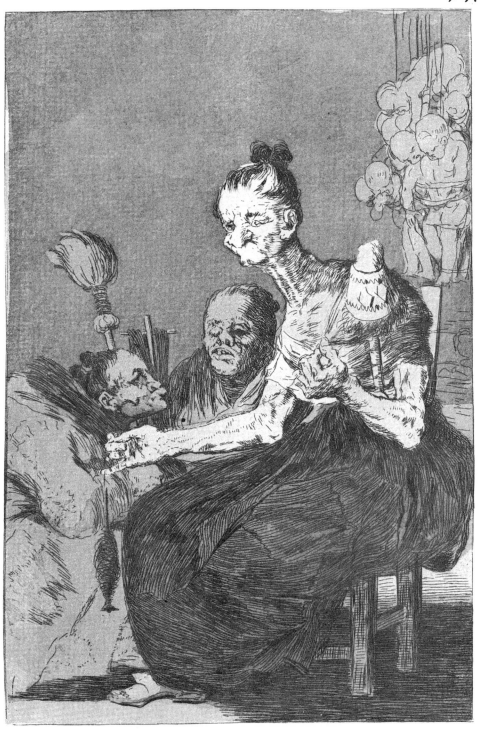

Hilan delgado.

[45] There is plenty to suck

Those who reach eighty suck little children; those under eighteen suck grown-ups. It seems that man is born and lives to have the substance sucked out of him. · *Las q.ᵉ llegan ā 80 chupan chiquillos: las q.ᵉ no pasan de 18 chupan a los grandes. Parece q.ᵉ el hombrᵉ nace y vive p.ᵃ ser chupado.*

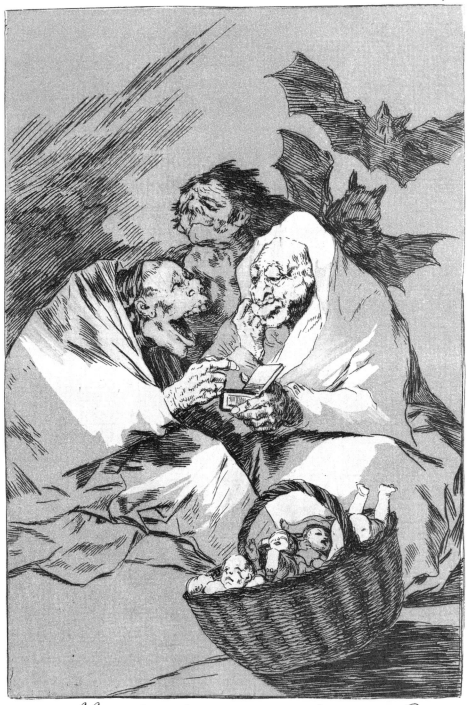

Mucho hay que chupar.

[46] Correction

Without correction and censure one cannot get on in any faculty, and that of witchcraft needs uncommon talent, application, maturity, submission and docility to the advice of the great Witch who directs the seminary of Barahona ·

Sin correc.ⁿ ni censura no se adelanta en ninguna facultad y la de la Bruger.ᵃ necesita particl.ʳ talento, aplicac.ⁿ edad madura, sumisi.ⁿ y docilid.ᵈ à los consej.ˢ del gran Brujo q.ᵉ dirige el semin.º de Barahona.

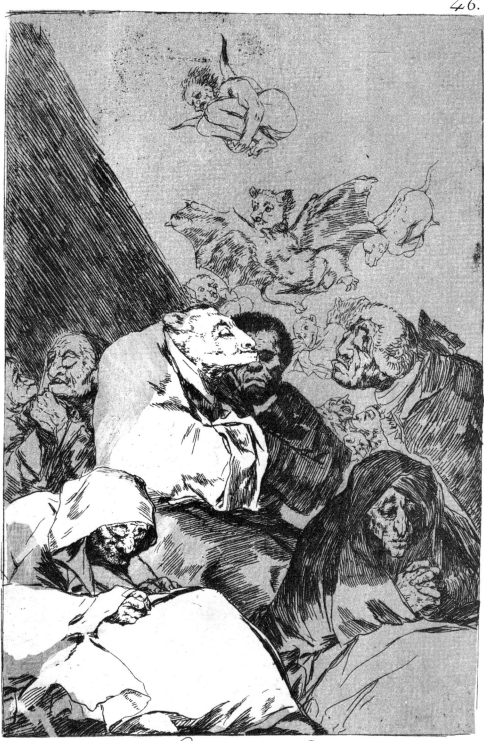

Correccion.

[47] A gift for the master

That is quite right; they would be ungrateful pupils not to visit their professor to whom they owe everything they know in their diabolical science · *Es muy justo: serìan discipulos ingratos si no visitarⁿ a su catedrᶜᵒ à quien deben todo lo qᵉ saben en su diabolica facultad.*

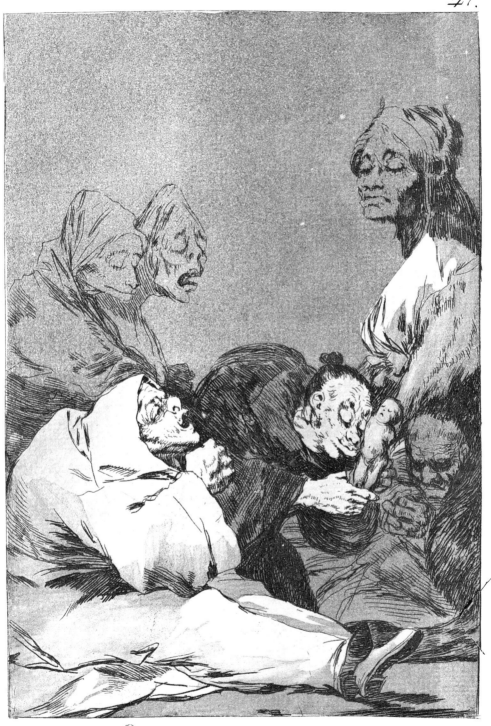

Obsequio á el maestro.

[48] Tale-bearers—Blasts of wind

The tale-bearing witches are the most irritating in all witchcraft and the least intelligent in that art; if they really knew something they wouldn't blast it about · *Los Bruxos soplones son los mas fastid.ˢ de toda la Brux.ᵃ y los menos yntelig.ˢ en aquel arte. Si supieran algo no se meterian à soplones.*

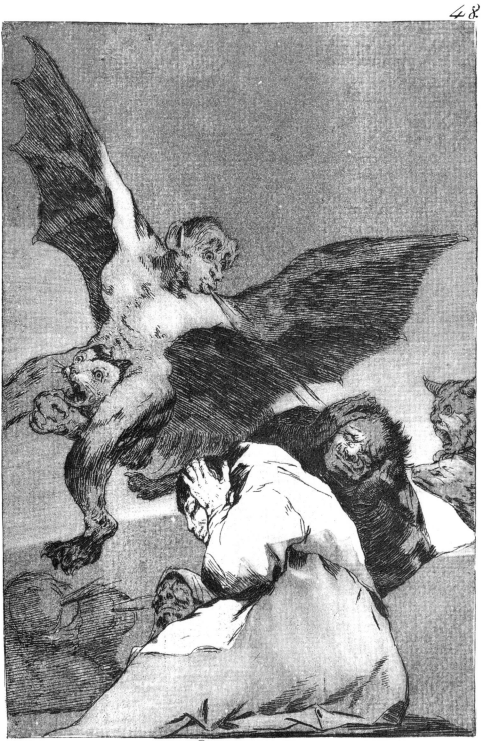

Soplones.

[49] Hobgoblins

Now this is another kind of people. Happy, playful, obliging; a little greedy, fond of playing practical jokes; but they are very good-natured little men · *Esta ya es otra gente Alegres, juguetones servicia⁵.; un poco golosos, amigos de pegar chascos; pero muy hombrecitos de bien.*

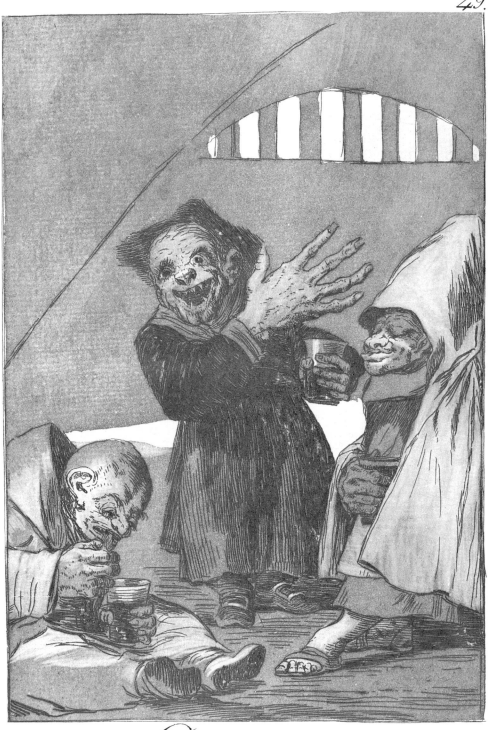

Duendecitos.

[50] The Chinchillas

He who hears nothing, knows nothing and does nothing, belongs to the numerous family of the Chinchillas, which has always been good for nothing ·
El que no oye nada ni sabe nada, ni hace nada, pertenece a la numerosa familia de los Chinchillas q.ᵉ nunca à servido de nada.

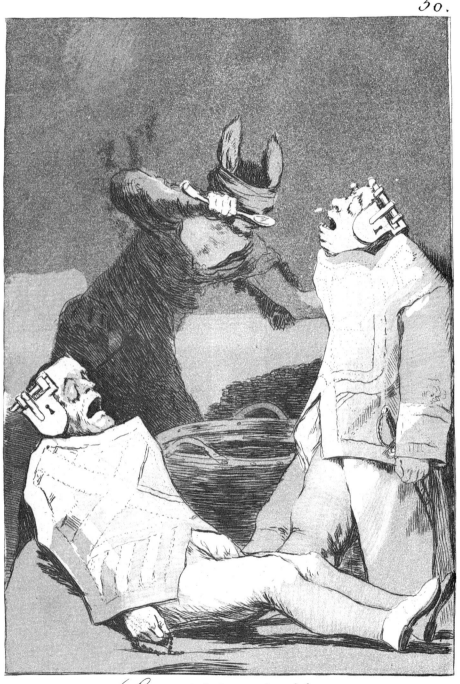

Los Chinchillas.

[5 1] They spruce themselves up

This business of having long nails is so pernicious that it is forbidden even in Witchcraft · *Esto de tener las uñas largas es tan perjudici! q.ᵉ aun en la Brux.ᵃ esta prohivido.*

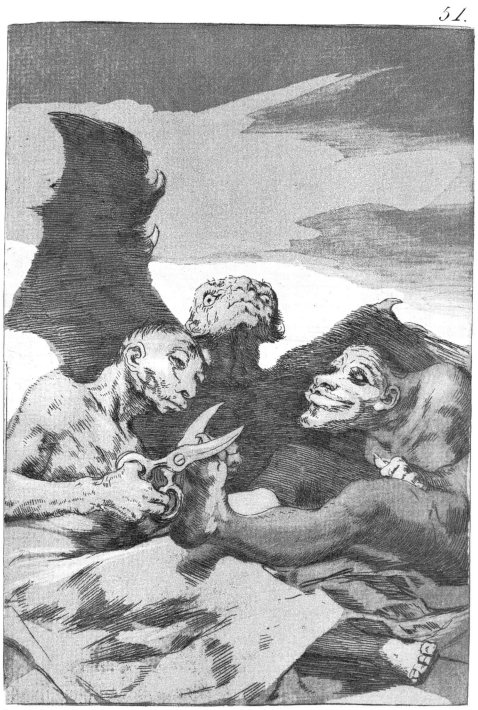

Se repulen.

[52] What a tailor can do!

How often can some ridiculous creature be suddenly transformed into a presumptuous coxcomb who is nothing but appears to be much. That is what can be done by the ability of a tailor and the stupidity of those who judge things by their appearance · *Quantas veces un bicho ridiculo se transf^{ma} de repente en un fantasmon q^e. no es nada y aparenta mucho. Tanto puede la habilid^d de un sastre y la boberia de quien juzga las cosas por lo q^e. parecen.*

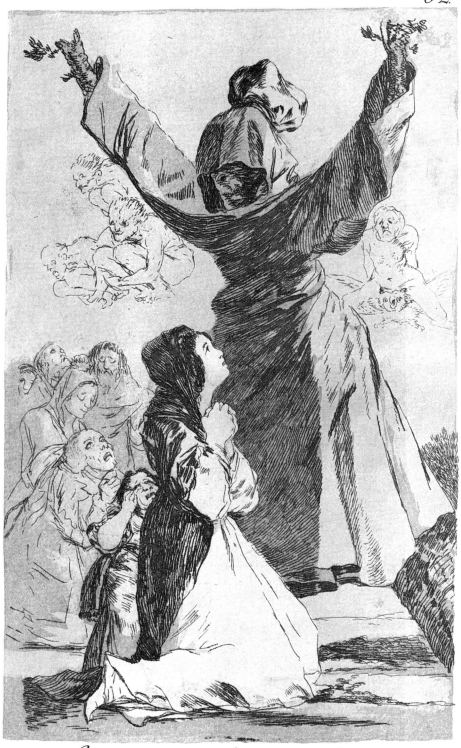

Lo que puede un Sastre!

[53] What a golden beak!

This looks a bit like an academic meeting. Perhaps the parrot is speaking about medicine? However, don't believe a word he says. There is many a doctor who has a "golden beak" when he is talking, but when he comes to prescriptions, he's a Herod; he can ramble on about pains, but can't cure them: he makes fools of sick people and fills the cemeteries with skulls · *Esto tiene trazas de junta academica. Quien sabe si el papagayo estara hablando de medicina? Pero no hay q.ᵉ creerlo sobre su palabra. Medico hay q.ᵉ q.ᵈᵒ habla es un pico de oro y q.ᵈᵒ receta un Érodes: discurre perf.ᵃm.ᵗᵉ de las dolencias y no las cura: enboba à los enfermos y atesta los Cementer.ˢ de calaberas.*

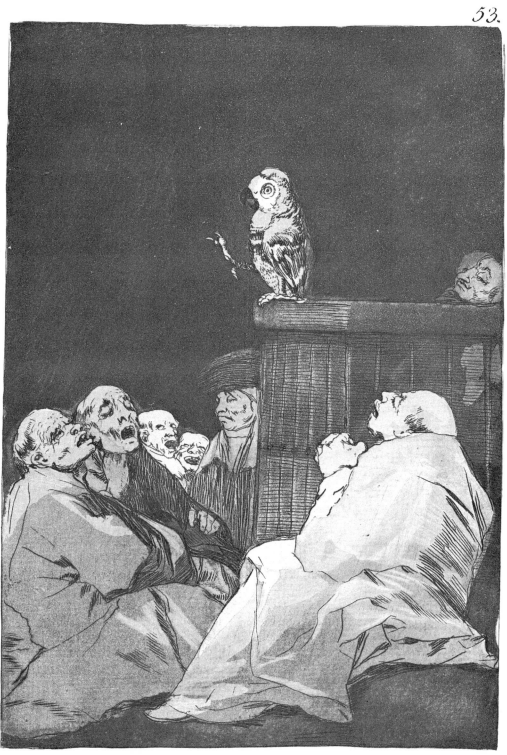

Que pico de Oro!

[54] The shamefaced one

There are men whose faces are the most indecent parts of their whole bodies and it would be a good thing if those who have such unfortunate and ridiculous faces were to put them in their breeches · *Hay hombres cuya cara es lomas indecente de todo su cuerpo y seria bien q̇ los q̇ las tienen tan desgraciada y ridicula se la metieran en los calzones.*

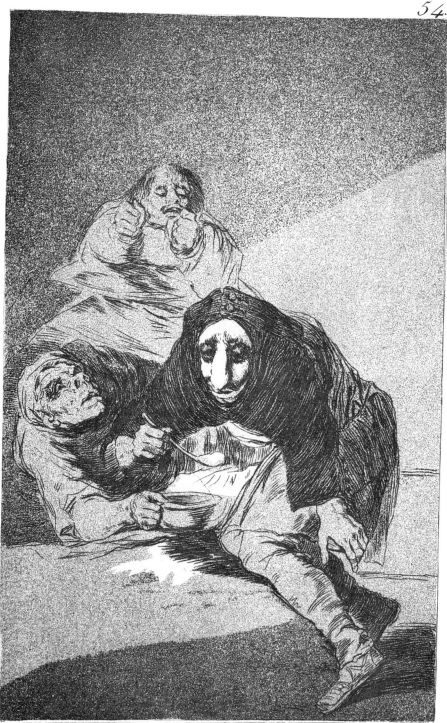

El Vergonzoso.

[55] Until death

She is quite right to make herself look pretty. It is her seventy-fifth birthday, and her little girl friends are coming to see her · *Hace muy bien de pònerse guapa. Son sus dias; cumple 75 años, y bendran las amigitas a verla.*

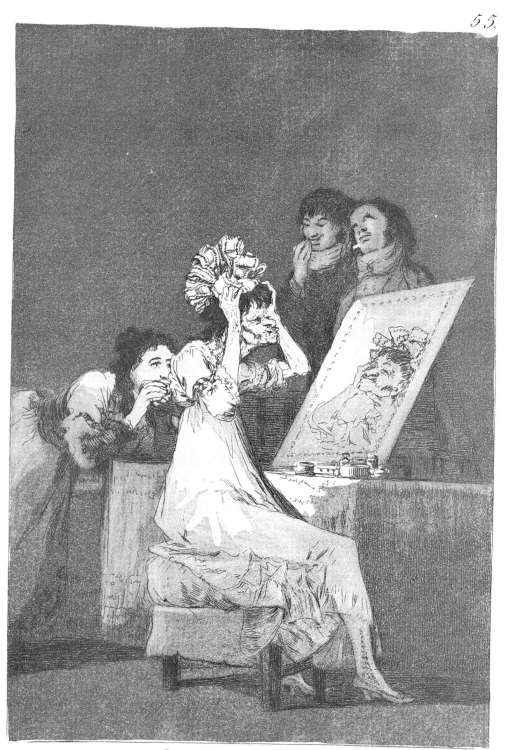

Hasta la muerte.

[56] To rise and to fall

Fortune maltreats those who court her. Efforts to rise she rewards with hot air and those who have risen she punishes by downfall · *La fortuna trata muy mal à quien la osequia. Paga con humo la fatiga de subir y al q°. ha subido le castiga con precipitarle.*

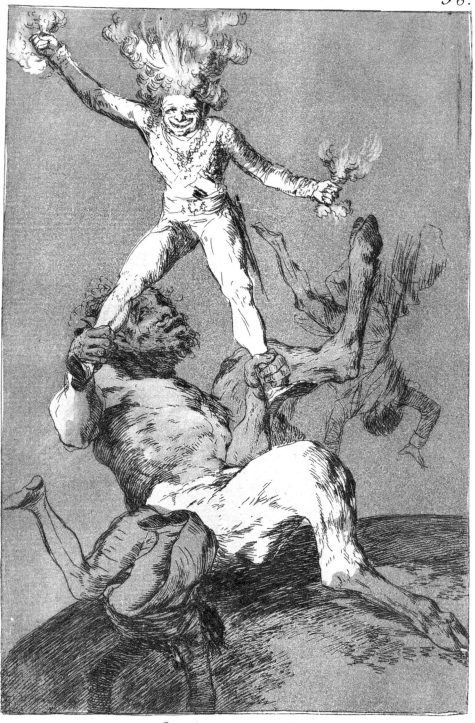

Subir y bajar.

[57] The Filiation

Here is a question of fooling the fiancé by letting him see, through her pedigree, who were the parents, grandparents, great-grandparents, and great-great-grandparents of the young lady. And who is she? He will find that out later · *Aqui se trata de engatusar al novio haciendole ver p.ᵣ la egecut.ᵃ quienes fueron los padres, abuelos, visabuelos y tartarab.ˢ de la Sᵗᵃ y ella quien es? luego la verā.*

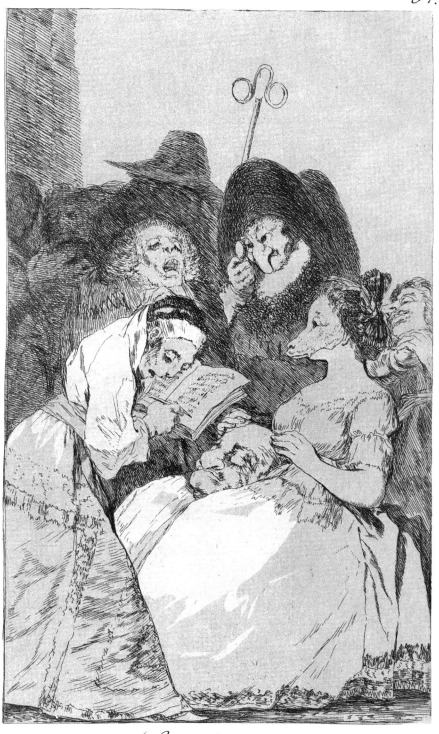

La filiacion.

[58] Swallow it, dog

He who lives amongst men will be irremediably vexed.* If he wants to avoid it he will have to go and live in the mountains, but when he is there he will discover that to live alone is vexatious · *El q.ᵉ viva entre los homb.ˢ sera gering.ᵈ.º irremedia.ᵉmente, si quiere evitarlo, habra de irse a habitar los montes, y q.ᵈ.º este alli conocera tanbien q.ᵉ esto de vivir solo es una geringa.*

*The commentary plays on the two meanings of the word "jeringar"—to syringe or to vex.

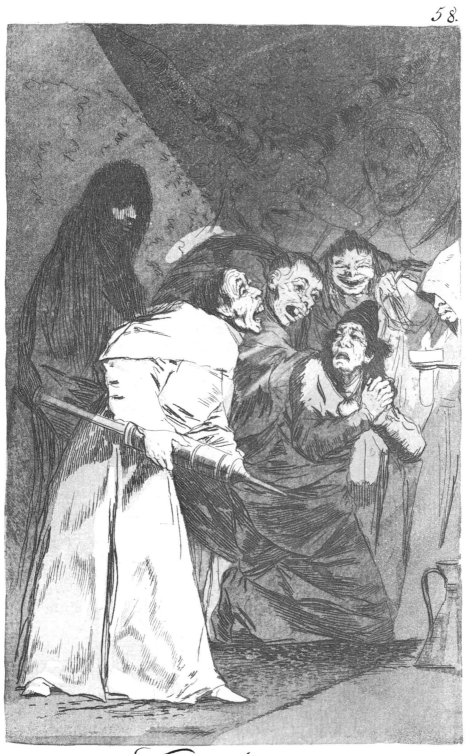

Tragala perro.

[59] And still they don't go!

He who does not reflect on the inconstancy of fortune sleeps peacefully while surrounded by dangers; he does not know how to avoid the danger which threatens him, and there is no misfortune which does not surprise him · *El q.ᵉ no reflexᵃ sobre la instabilidad de la fortuna duerme tranquilo rodeado de peligros: ni sabe evitar el daño q.ᵉ hamenaza ni hay desgracia q.ᵉ no le sorprenda.*

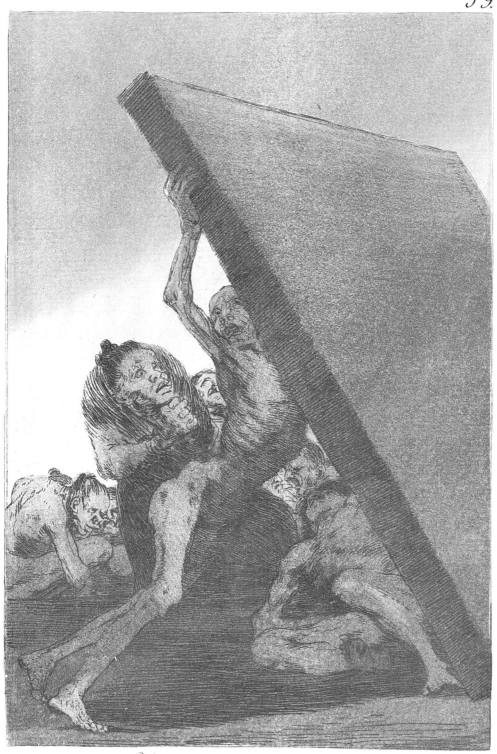

Y aun no se van!

[60] Trials

Little by little she is making progress. She is already making her first steps and in time she will know as much as her teacher • *Poco a poco se va adelantando, ya hace pinitos y con el ti(em)po sabra tanto como su maestra.*

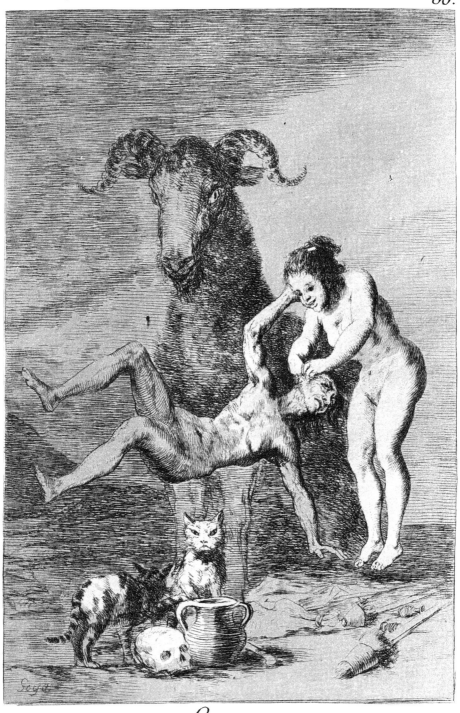

Ensayos.

[61] They have flown

The group of witches which serves as pedestal for this fashionable lady is put there for ornament rather than for use. There are heads so full of inflammable gas that they need neither balloons nor witches to make them fly · *El grupo de brujas qᵉ. sirbe de peana à la petrimᵗʳ.ᵃ mas qᵉ. necesidad es adorno. Hay cabezas tan llenas de gas inflamable qᵉ. no necesitan pᵃ. volar ni globo ni brujas.*

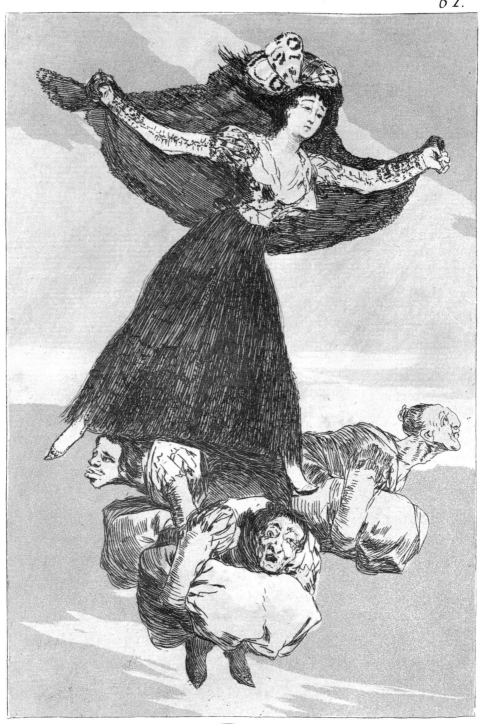

Volaverunt.

[62] Who would have thought it!

See here is a terrible quarrel as to which of the two is more of a witch. Who would have thought that the screechy one and the grizzly one would tear each other's hair in this way? Friendship is the daughter of virtue. Villains may be accomplices but not friends · *Ve aqui una pelotera cruel sobre qual es mas bruja de las dos quien diria q.ᵉ la petiñosa y la crespa se repelaran asi? la amistad es hija de la virtud: los malbados pueden ser complices pero amigos no.*

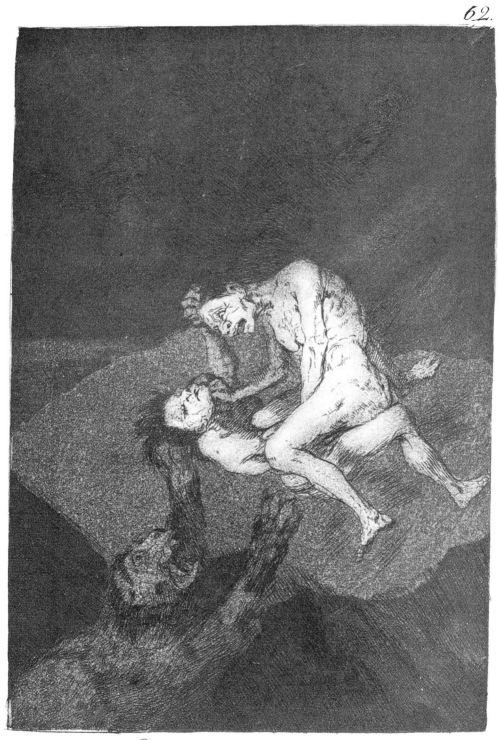

Quien lo creyera!

[63] Look how solemn they are!

The print shows that these are two witches of means and position who have
gone out to take a little exercise on horseback · *La estampa indica qᵉ. estos son
dos brujos de conbeniencias y autorᵈ. qᵉ. han salido à hacer un poco de exercicio a
caballo.*

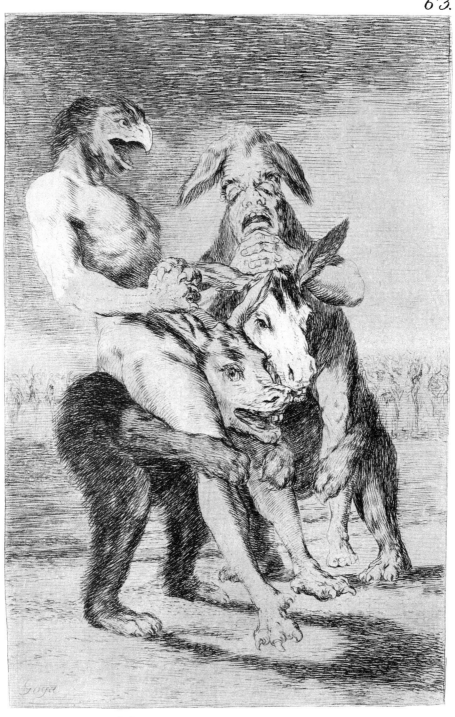

Miren que grabes!

[64] Bon voyage

Where is this infernal company going, filling the air with noise in the darkness of night? If it were daytime it would be quite a different matter and gun shots would bring the whole group of them to the ground; but as it is night, no one can see them · *A donde irà esta caterba ynfer!., dando aullidos p! el aire, entre las tinieb! de la noche. Aun si fuera de dia ya era otra cosa y a fuerza de escopet!., caeria al suelo toda la gorullada, pero como es de noche, nadie les ve.*

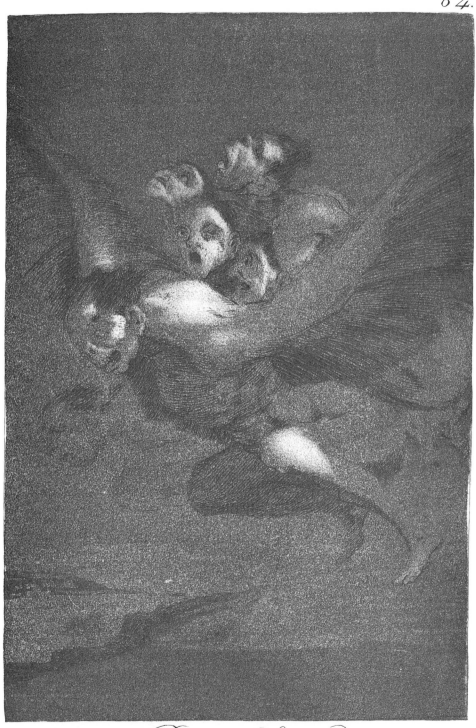

Buen Viage.

[65] Where is mother going?

Mother has dropsy and they have sent her on an outing. God willing, she may recover · *Mamà està ydropica y le han mandado pasear. Dios quiera qᵉ se alibie.*

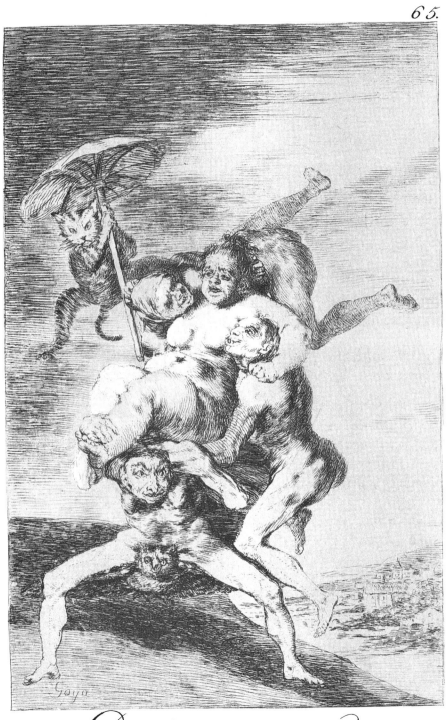

Donde vá mamá?

[66] There it goes

There goes a witch, riding on the little crippled devil. This poor devil, of whom everyone makes fun, is not without his uses at times · *Ahi ba una bruja, a caballo en el diablo cojuelo. Este pobre diablo de quien todos hacen burla, no deja de ser util algunas veces.*

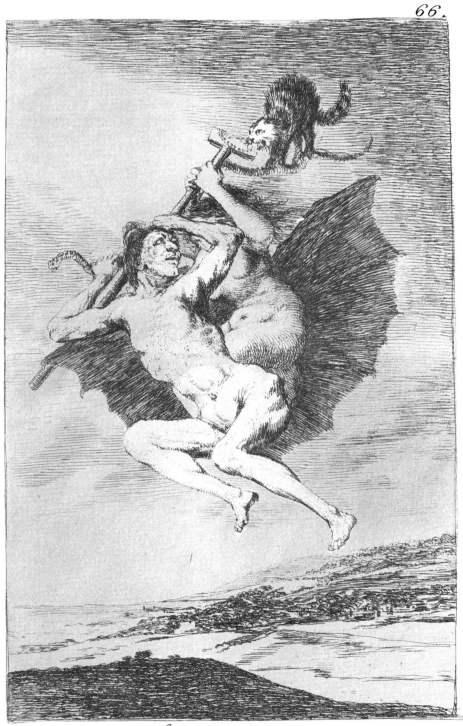

Allá vá eso.

[67] Wait till you've been anointed

He has been sent out on an important errand and wants to go off half-anointed. Even among the witches, some are hare-brained, impetuous, mad cap, without a scrap of judgment. It's the same the world over · *Le embian ā un recado de importancia y quiere irse à medio untar. Entre los brujos los hay tanbien troneras, precipitados, botarates, sin pizca de Juicio: todo el mundo es pais.*

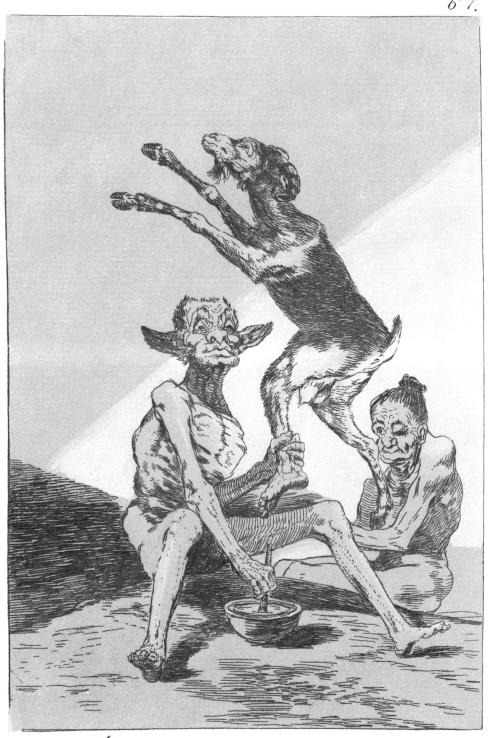

Aguarda que te unten.

[68] Pretty teacher!

The broom is one of the most necessary implements for witches; for besides being great sweepers, as the stories tell, they may be able to change the broom into a fast mule and go with it where the Devil cannot reach them · *La escoba es uno de los utensilios mas necesarios a las brujas, porq.ᵉ ademas de ser ellas grandes barrenderas (como consta p.ʳ las istorias talbez conbierten la escoba en mula de pasa y van con ella q.ᵉ el Diablo no las alcanzara.*

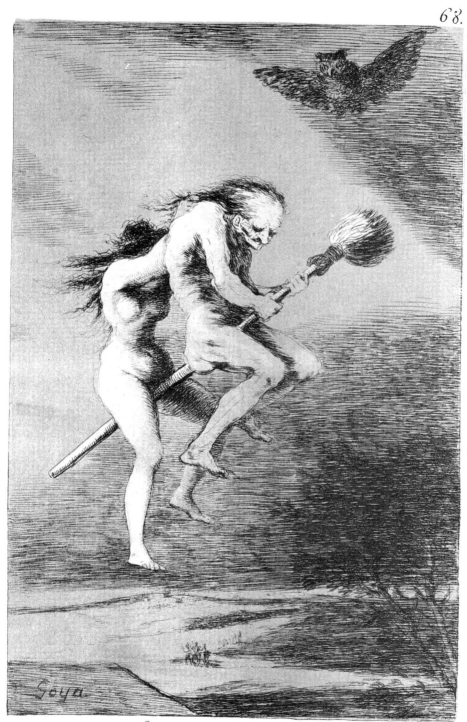

Linda maestra!

[69] Blow

No doubt there was a great catch of children the previous night. The banquet which they are preparing will be a rich one: "Bon appetit" · *Gran pesca de chiquillos hubo sin duda la noche anterior el banquete qᵉ. se prepara sera suntuoso. Buen probecho.*

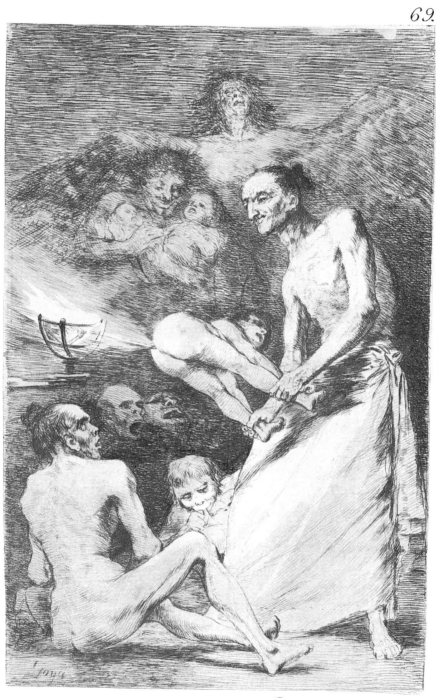

Sopla.

[70] Devout profession

"Will you swear to obey and respect your masters and superiors, to sweep the garrets, to spin tow, to ring bells, to howl, to yell, to fly, to cook, to grease, to suck, to bake, to blow, to fry, everything and whatever time you are ordered to?" "I swear." "Well then, my girl, you are now a witch. Congratulations"
• *Juras obedecer y respetar a tus maestras y superiores? barrer desbanes, hilar estopa, tocar sonajas, ahullar, chillar volar guisar, untar, chupar, cocer, soplar, freir, cada y qdo se te mande? Juro. Pues hija ya eres Bruja. Sea en ora buena.*

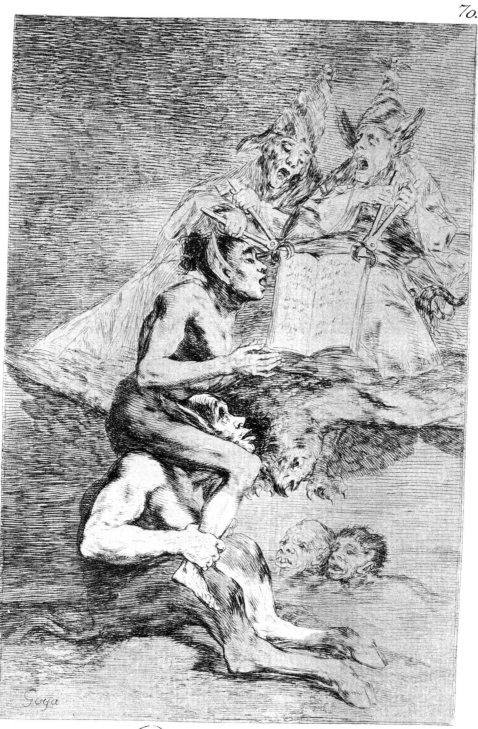

Devota profesion.

〖71〗 When day breaks we will be off

Even if you hadn't come you wouldn't have been missed · *Y aun q.ᵉ no hubierais venido no hicierais falta.*

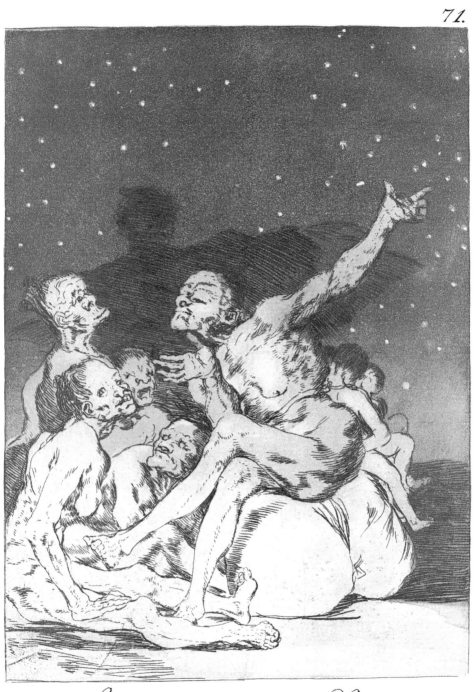

Si amanece; nos Vamos.

[72] You will not escape

She who wants to be caught never escapes · *Nunca se escapa la qᵉ se quiere dejar coger.*

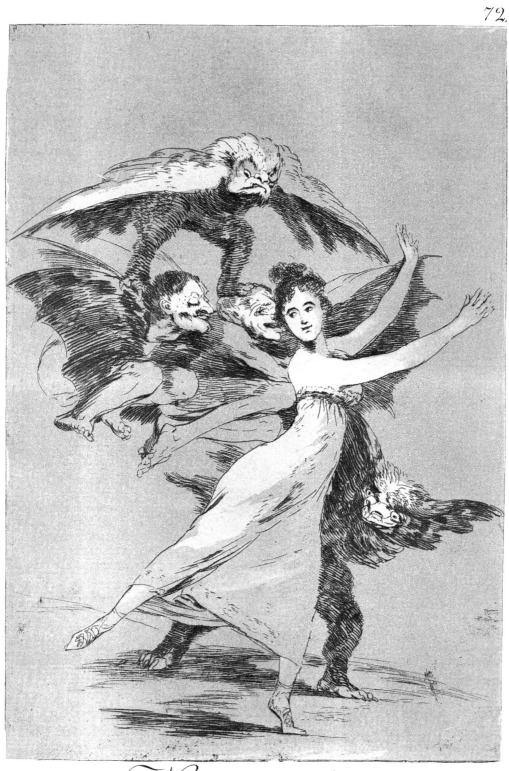

No te escaparás.

[73] It is better to be lazy

If the more he works the less he likes it, he is quite right to say, "It is better to be lazy" · *Si el q.ᵉ mas trabaja es el q.ᵉ menos goza, tiene razon mejor es olgar.*

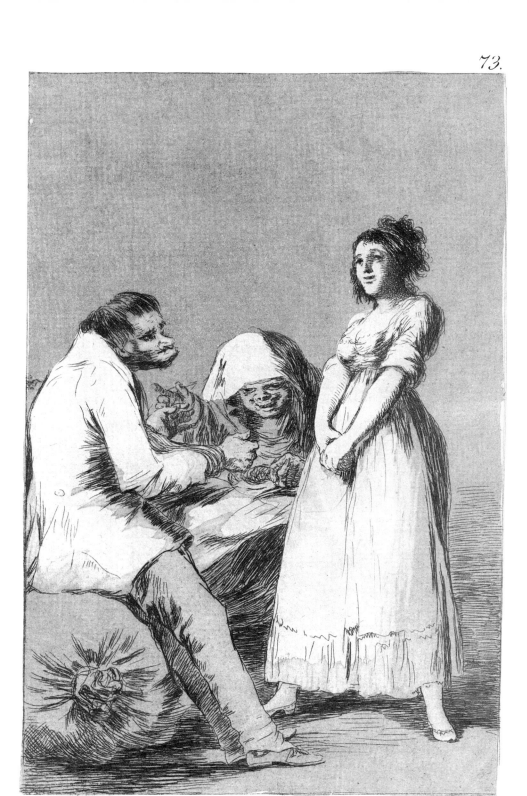

Mejor es holgar.

[74] Don't scream, stupid

Poor Paquilla! She was looking for the footman and runs into the goblin, but don't be afraid: it's plain that Martinico is in a good mood and won't do her any harm · *Pobre Paquilla! que yendo a buscar al lacayo se encuentra con el duende, pero no hay q^e. temer: se conoce q^e. Martinico esta de buen humor y no le harà mal.*

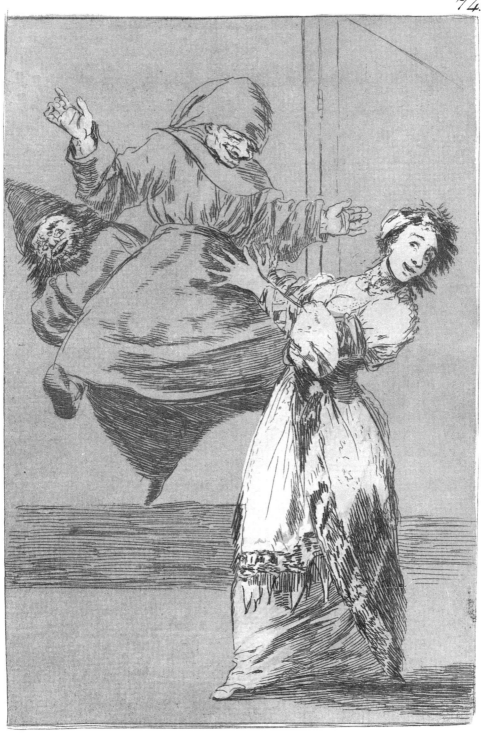

No grites, tonta.

[75] Can't anyone untie us?

A man and a woman tied together with ropes, struggling to get loose and crying out to be untied quickly? Either I am mistaken, or they are two people who have been forced to marry • *Un hombre y una muger atados con sogas forcejando p.ª soltarse y gritando q.ᵉ los desaten a toda prisa? O yo me equiboco o son dos casados p.ª fuerza.*

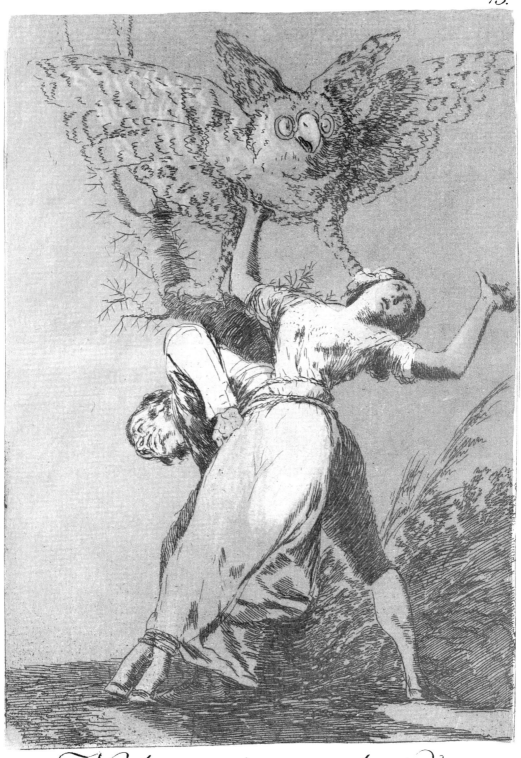

¿No hay quien nos desate?

[76] You understand?... well, as I say ... eh! Look
 out! otherwise ...

The cockade and baton make this stupid bore think that he is a superior
being, and he abuses the office entrusted to him to annoy everyone who knows
him; he is proud, insolent, vain with all who are his inferiors; servile and
abject with those who are his superiors · *La escarap^la y el bast^n. le hacen creer
à este majadero q^e. es de superior natural^za. y abusa del mando q^e. se le confia p^a.
fastid^r. à quantos le conoscen, sobervio, insol^te. y vano, con los q^e. le son inferiores,
abatido y bil con los q^e. pueden mas q^e. el.*

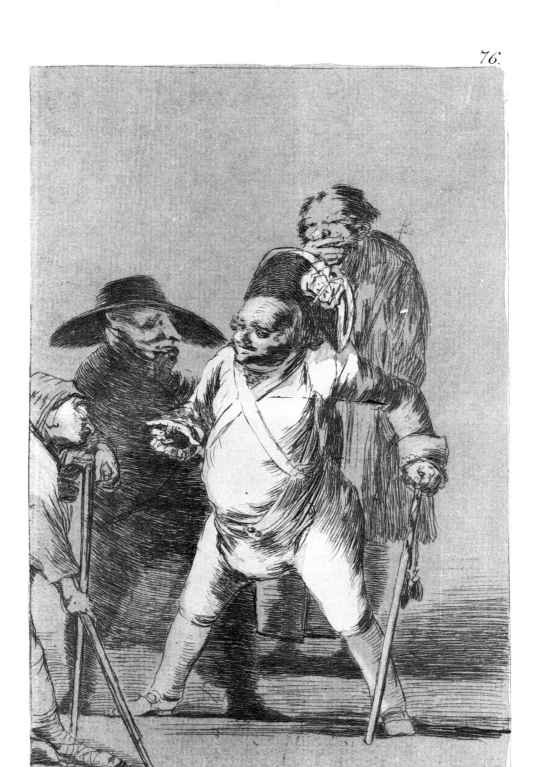

¿Està Vm.ᵈ pues, Como digo.. eh¡ Cuidado! si nó!..

[77] What one does to another

It is the way of the world. People jest and fight with one another. He who yesterday played the part of the bull, today plays the "caballero en plaza." Fortune presides over the show and allots the parts according to the inconstancy of her caprices · *Asi va el mundo. Unos à otros se burlan y se torean El qᵉ ayer hacia de toro hoy hace de caballero en plaza. La fortuna dirige la fiesta y distribuye los papeles segun la inconstancia de sus caprichos.*

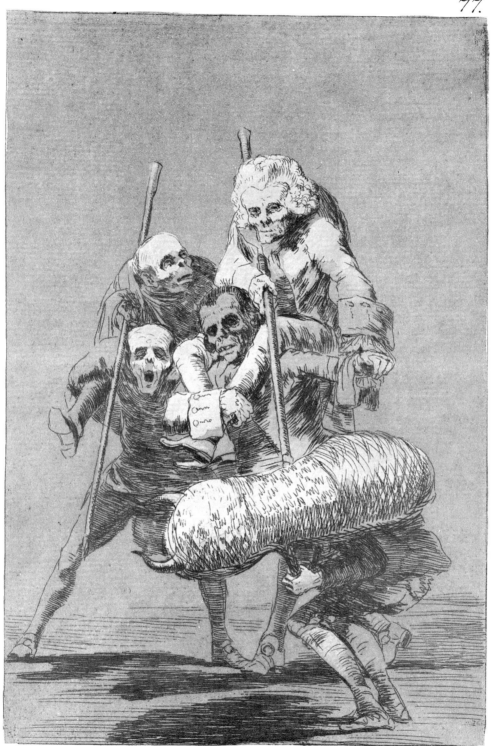

Unos à otros.

[78] Be quick, they are waking up

The goblins are the most industrious and obliging people there are. As the maid keeps them happy, they scour the pot, cook the vegetables, wash up, sweep and hush the child. It has often been disputed whether they are devils or not; don't let us deceive ourselves. Devils are those who spend their time doing harm, or hindering others from doing good, or doing nothing at all ·
Los duend^{tos} son la gente mas acendosa y servic! q^e p^{de} hallarse como la cri^{da} los tenga content^s, espum^n la olla, cuecen la verd^a frieg^n barr^n y acallan el niño. Mucho se à disputado si son Diab^s o no; deseng^{nos}, los diab^s son los q^e se ocup^n en hac^r mal, o en estorbar q^e otros agan vien, o en no hacer nada.

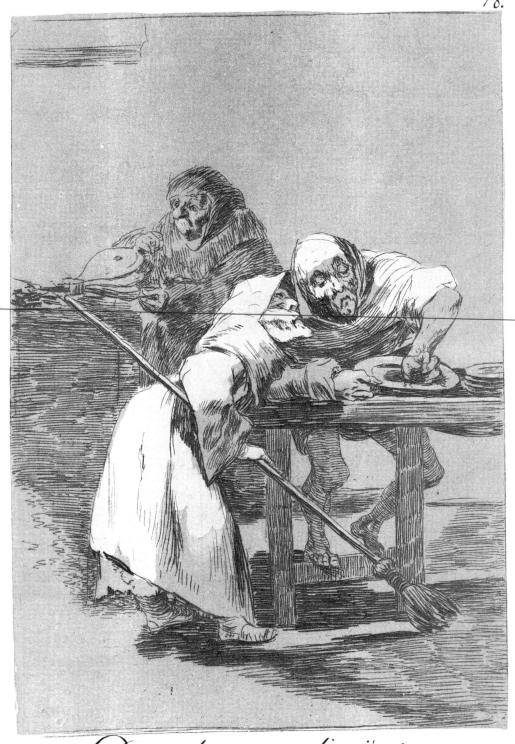

Despacha, que dispiertan.

[79] No one has seen us

And what does it matter if the goblins go down to the cellar and have four swigs, if they have been working all night and have left the scullery like gleaming gold? · *Y que imp^{ta}. q^e. los Mart^{cos} baxen à la bodega y echen 4 tragos si an trabaj^{do}. toda la noche y queda la espetera como un ascua de oro?*

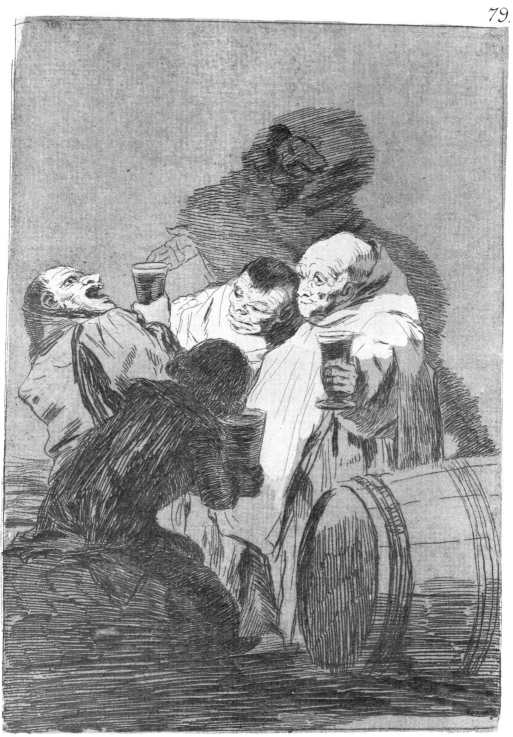

Nadie nos ha visto.

[80] It is time

Then, when dawn threatens, each one goes on his way, Witches, Hobgoblins, apparitions, and phantoms. It is a good thing that these creatures do not allow themselves to be seen except by night and when it is dark! Nobody has been able to find out where they shut themselves up and hide during the day. If anyone could catch a denful of Hobgoblins and were to show it in a cage at 10 o'clock in the morning in the Puerta del Sol, he would need no other inheritance · *Luego q*ᵉ *amanece huyen cada cual p*ᵗ *su lado, Brujas, Duen*ˢ *visiones y fantasmas. Buena cosa es q*ᵉ *esta gente no se dexe ver sino de noche y ā obscuras! Nadie à podido aberiguar en donde se encierran y ocultan durante el dia. El q*ᵉ *lograse cojer una madriguera de Duendes y la enseñare dentro de una jaula a las 10 de la mañana en la Puerta del Sol, no necesitaba de otro mayorazgo.*

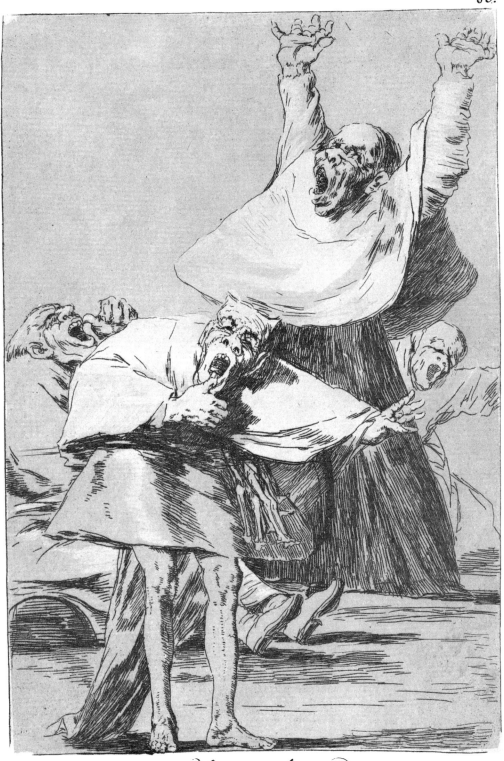

Ya es hora.

Preliminary wash drawing by Goya for "El amor y la muerte," Plate 10 of *Los Caprichos* [courtesy Mr. Philip Hofer, Cambridge, Mass.]

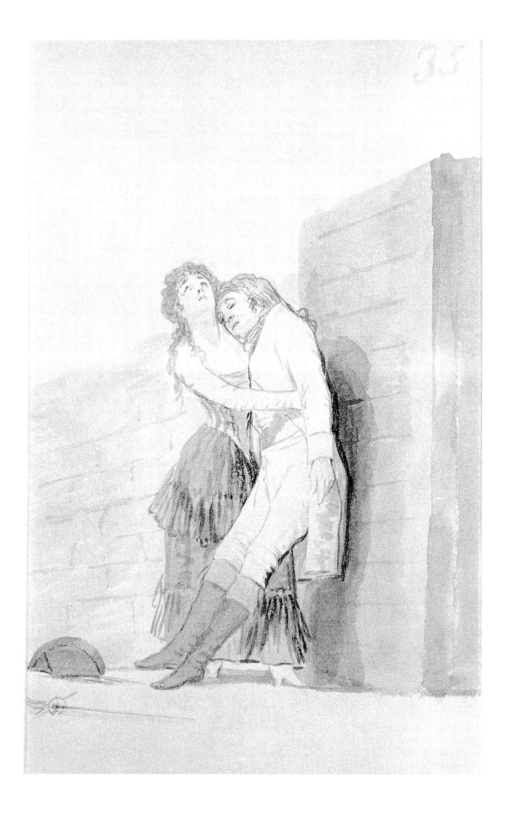

Unique proof of an earlier version of "Aquellos polbos,"
Plate 23 of *Los Caprichos* [courtesy Cabinet des Estampes,
Bibliothèque Nationale, Paris]

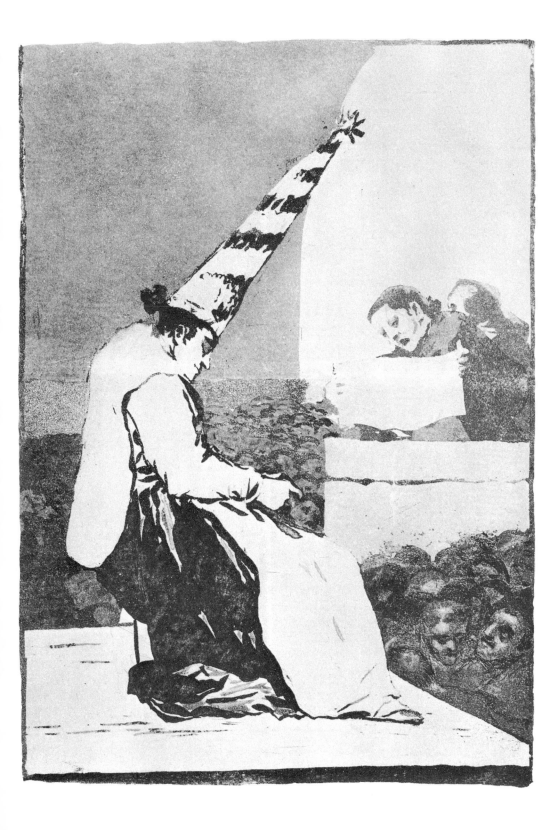

Unique proof of "Old Woman and a Gallant," from a plate probably intended for the *Caprichos* series [courtesy Cabinet des Estampes, Bibliothèque Nationale, Paris]

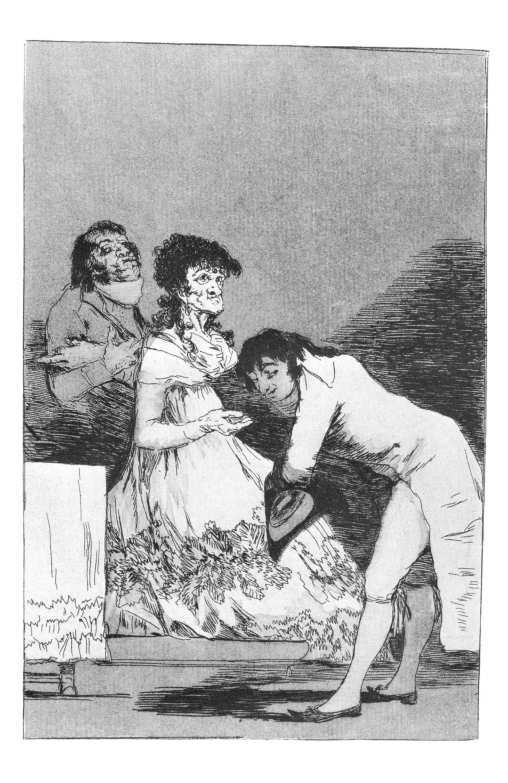

Unique proof of "Sueño de la mentira y la ynconstancia" [Dream of lies and inconstancy], from a plate probably intended for the *Caprichos* series [courtesy Gabinete de Estampas, Biblioteca Nacional, Madrid]

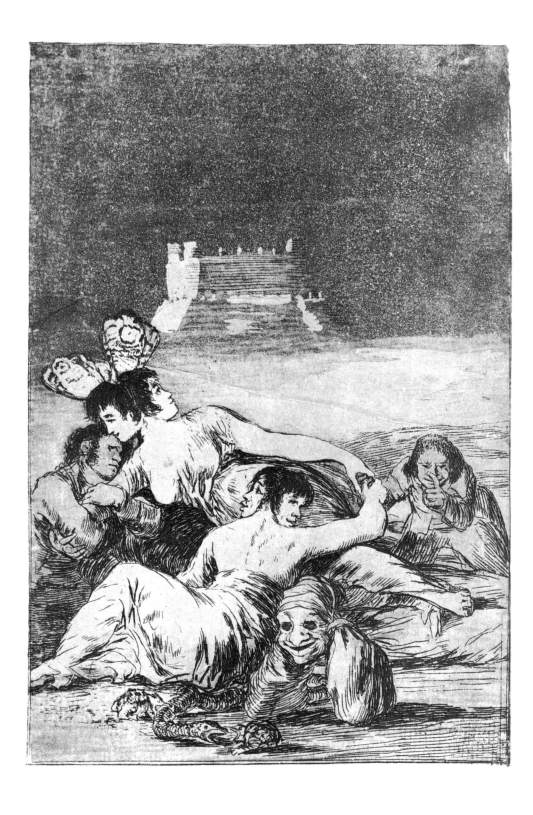

Unique proof of "Woman in Prison," possibly an earlier version of "Por que fue sensible," Plate 32 of *Los Caprichos* [courtesy Gabinete de Estampas, Biblioteca Nacional, Madrid]

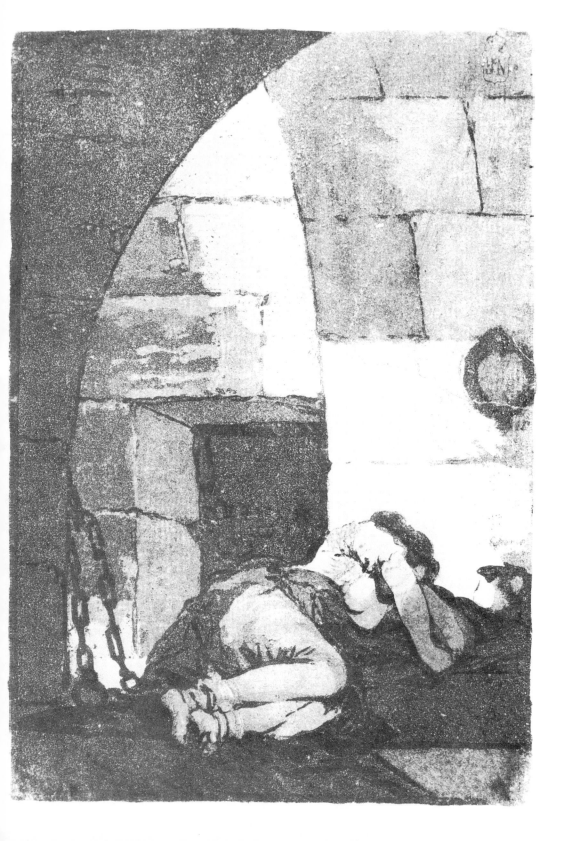

Unique proof of "Women Weeping over an Injured Dog,"
from a plate probably intended for the *Caprichos* series
[courtesy Gabinete de Estampas, Biblioteca Nacional, Madrid]

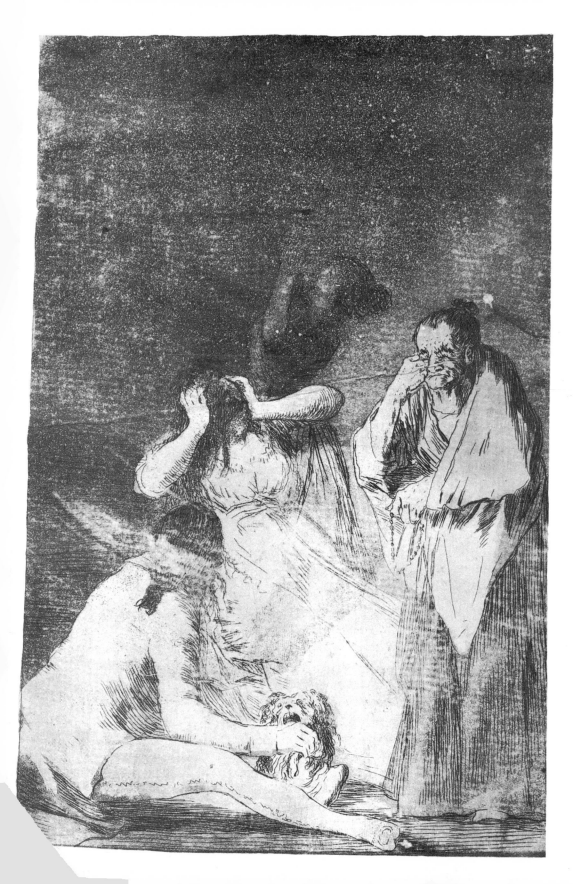